Eerie Erie

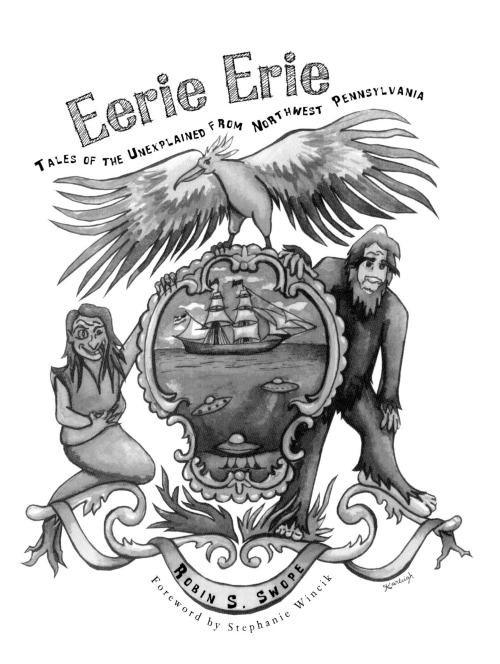

Eerie Erie

TALES OF THE UNEXPLAINED FROM NORTHWEST PENNSYLVANIA

ROBIN S. SWOPE

Foreword by Stephanie Wincik

THE
History
PRESS

Published by The History Press
Charleston, SC 29403
www.historypress.net

Copyright © 2011 by Reverend Robin S. Swope
All rights reserved

Cover design and illustrations by Karleigh Hambrick.

First published 2011

Manufactured in the United States

ISBN 978.1.60949.356.1

Swope, Robin S.
Eerie Erie : tales of the unexplained from northwest Pennsylvania / Robin S. Swope.
p. cm.
Includes bibliographical references.
ISBN 978-1-60949-356-1
1. Ghosts--Pennsylvania--Erie County. 2. Haunted places--Pennsylvania--Erie County. 3. Parapsychology--Pennsylvania--Erie County. 4. Curiosities and wonders--Pennsylvania--Erie County. 5. Ghosts--Pennsylvania--Erie. 6. Haunted places--Pennsylvania--Erie. 7. Parapsychology--Pennsylvania--Erie. 8. Curiosities and wonders--Pennsylvania--Erie. 9. Erie County (Pa.)--Social life and customs--Anecdotes. 10. Erie (Pa.)--Social life and customs--Anecdotes. I. Title.
BF1472.U6S89 2011
133.109748'99--dc23
2011021182

To Stephanie Wincik, who introduced us all to the eerie side of Erie County, Pennsylvania.

Contents

Foreword, by Stephanie Wincik 9
Acknowledgements 13
Introduction 15

Part I: Historical Mysteries
The Giant Mound Builders of Erie County 17
The Lost Graveyards of Erie 27
The Lake Erie Storm Hag 35
Lake Erie's Ghost Ship 40
The Forgotten Dead of Graveyard Pond 44

Part II: Haunted Places
The Vampire's Crypt of Erie Cemetery 49
The Haunted Church on Peach Street 53
Recently Lost Historic Haunted Places 62

Part III: UFOs
Close Encounter at Presque Isle 67
A Hidden Underwater UFO Base in Lake Erie 76

Part IV: Strange Creatures
Beware the Phantom Panthers 83
Bigfoot Lurks in Erie County 91
Strange Birds Wing Across the County 95

Contents

Conclusion 103
Bibliography 107
About the Author 111

Foreword

First, for those of you, like myself, who routinely skip the foreword of a new book in favor of jumping right to the heart of it, I thank you for taking a few moments to read these pages. That being said, let's get right into discussing why you are sure to find Robin Swope's new book, *Eerie Erie*, an enjoyable read. For reasons that are still unclear to me, Erie County, Pennsylvania, is a hotbed of paranormal activity. As a collector of local ghost stories and legends for more than a decade, I am continually astounded by the sheer number of ghostly tales, haunted houses, UFO sightings and just plain weird occurrences that have been reported to me by ordinary people living in this area over the years.

When my first book, *Ghosts of Erie County*, was published in 2002, I admit that it was a bit of a struggle at first to persuade people to allow me to include their stories in the book. It's not that most folks don't have a supernatural experience or two (or three) to report; almost everyone does. The problem is—or at least it was back then—that many people are reluctant to tell anyone about their experiences for fear of being ridiculed. I am happy to report that all of that has changed dramatically in recent years. On any given night flipping through channels on cable TV, it is rare not to find at least two or three programs focusing exclusively on ghost stories and paranormal investigations. Within the span of a few short years, interviewing individuals about their ghost stories has become a much easier task. In fact, these days, having a real-life supernatural experience to share has become a very cool thing indeed.

So how and why did attitudes toward unexplained phenomena change so quickly? I think there are a couple of possible explanations. First, widespread availability of the Internet has provided the general public with access to an incredible amount of information in a very short period of time. I believe that this rapid and continuous influx of knowledge is expanding our consciousnesses in ways that we are only beginning to understand. No longer are our minds focused exclusively on what is happening in our own lives or even in our own community. Suddenly we find ourselves thrust into a much larger, global community, where new ideas and innovative thinking affect us every day, whether we are consciously aware of them or not.

Secondly, the field of quantum physics is beginning to play a major role in altering our long-held beliefs about how the natural world works. Many of the concepts that we have taken for granted for years as being absolutely true—simply because that's what the scientists told us—are now being proven false. For example, how many of us still believe what we originally learned in science class about atoms? Were we not always taught that atoms, electrons and protons are the smallest particles known to man? Not true—now quantum physicists have learned that much smaller particles exist and that they behave in extraordinarily unexpected ways. These tiny particles seem to react to human observation—in other words, the particles that make up the world around us have the ability to change their activity from moment to moment, depending on who is looking at them. This discovery alone has amazing implications. Is it possible that humans can somehow affect their surroundings by using their thoughts alone?

Sounds like science fiction, right? Even so, I'm sure that the technology we take for granted in our modern world would have been regarded as science fiction by human beings as recently as a couple of centuries ago. Certainly I am not a physicist, and I will be the first to admit that the bulk of the scientific data I read about goes right over my head. However, I have gleaned enough to understand that quantum physics may help provide an explanation for much of what we currently refer to as "supernatural" phenomena, as well as providing the means for us as human beings to eventually change our world for the better.

Finally, I am convinced that at least part of the current explosion of interest in studying and investigating paranormal activity is a reflection of our own collective, albeit subconscious, knowledge that we are on the verge

of a huge breakthrough in our ability to understand the world around us. As recently as one hundred years ago, observing a microwave oven heating a cup of coffee would probably have been considered a supernatural or magical event, despite the fact that microwaves have always existed, all around us. The same goes for television and radio signals, microbes and the list goes on. Is it not logical to assume that at some point, possibly in the near future, occurrences that we now deem "supernatural" will simply be understood as being part of the natural world?

This increasing acceptance of and public fascination with all things paranormal, coupled with a generous dose of Erie County's rich history, has laid the groundwork for Robin's exciting new volume of supernatural tales and local legends. Erie's position on the banks of Presque Isle certainly lends itself well to the maritime theme you will find woven through some of the accounts in this book. Stories passed down from our Native American ancestors have also had an influence. And if you happen to find the idea of beings from other planets visiting our shores appealing, be sure to check out Robin's updated version of the 1966 UFO sighting at Beach 6. So, whether your interest lies in Bigfoot sightings, Erie County folklore or just straight-up ghost stories, you are sure to find something to fire your imagination in this absorbing collection. Because even if at some point we do come to understand paranormal phenomena as just normal phenomena, never fear—humankind is a species of storytellers, and we will always find new mysteries with which to delight, entertain and frighten ourselves. Enjoy!

Stephanie Wincik

Acknowledgements

I would like to thank the following, who have helped me in research, support and kindness during the writing of this book: Rick Stokes of the *Anomalist*, who introduced my blog to the world; author Brad Steiger; Tim Binnall of *Coast to Coast* AM's website news feed; author Stephanie Wincik; Chris Millette, Lindsey Poisson and Jeffrey Hileman from the *Erie Times News*; Ann Marie Schlinderwein of the Erie County Library; Eric Altman of the Pennsylvania Bigfoot Society; Patrick McLeod; paranormal investigators Frank Grande of Erie County Paranormal (ECP), Jerry Thompson of Pennsylvania Society for Paranormal Research (Pas Fpr) and James McCann of A Paranormal Group Erie County PA (APG/ECP); the Seip family; Fred Lane; Dr. Brian Widbin and Dr. William Crockett of Alliance Theological Seminary; Steven Duda; Mel "Butch" Wellman; Frank Edwards; Cheryl and Charles Pierce, as well as the Pierce family; Denise Gibson; Craig Fischer; and finally the Church Council at St. Paul's United Church of Christ, along with the entire congregation, for blessing me with a loving and encouraging church home.

Introduction

E rie County has a rich history, and when one takes a close look at the old journals and books that detail the county's beginnings, you encounter a few surprises. While some would dismiss some of the legends and stories detailed in this book as superstitious nonsense, they have been and still remain a legacy of old Erie. Some of these stories are well documented in the many histories of Erie County that were published at the turn of the nineteenth century. Others are old lore that have no documentation but rather have lingered on for centuries by word of mouth in chilling stories told around the hearth or campfire.

Whatever your take on the supernatural and unexplained, many have had personal encounters with the unknown that have twisted their outlook on the world as they knew it. When they encounter the unexplainable, their rational minds seek an explanation. Often, no matter how many times they go over their memories and the details of an encounter, it defies rational explanation. The strange thing is that some people can experience the odd and astounding and just shrug it off as something odd but insubstantial. We live in a rational world. The twenty-first-century human lives in a world of scientific explanation, rational thought and humanistic ideals. The unexplained does not fit into his box. The supernatural is in the realm of myth and superstition.

Even many Christians tend to limit their worldview when it comes to the supernatural, even though the core of our faith is the death and resurrection

of Jesus Christ, true God and true man. The incarnation and resurrection of Christ are the most astonishing supernatural events in history, yet many Christians will categorize the unexplained with the occult. Some do this out of theological misunderstanding and others from fear of what the unknown will do to their faith. But if you try to put God in a box, you often find that you are the one in the box. God has made a universe of mystery and wonder. God has made man the most curious of species. We were made to seek out and understand the unknown.

Herein, then, you shall find an odd assortment of the strange history, the weird encounters and the eerie phenomena that permeate Erie County. Sometimes exact locations of these strange occurrences are listed. Please respect the owners' private properties; I do not advocate or condone trying to access any person's or organization's private or restricted property without proper authorization and explicit consent. You ought to be looking for mysteries, not trouble. But you don't have to look far to find the eerie in Erie County, it could be right in your own backyard.

Historical Mysteries

THE GIANT MOUND BUILDERS OF ERIE COUNTY

When the first European settlers came to Erie County in the mid-seventeenth century, they found a landscape that was quite different than it is today. Of course, the forest filled the area; it was a wild borderland at that time. One odd difference was in the remarkable Indian burial mounds that littered the landscape. In twenty-first century Erie County, there are only a few scattered remnants of these once plentiful burial sites. All of the early histories of the county remark on

the large mounds that the pioneers had found, as well as how they were quickly disappearing, victims of the farmer's plow, the builder's shovel and the vandal's curiosity.

There were some strange discoveries found when the pioneers first opened the mounds. It seems that they were not isolated to Erie, but research has shown that the oddities abounded in our county. In the mix of pottery, the occasional bead necklace and arrowheads laid to rest with the graves of the native tribal population, the settlers found amazing discoveries. They unearthed gigantic human skeletons. The Warner and Beers Company in its *History of Erie County* recounted that

> *when the roadway of the Philadelphia & Erie road, where it passes through the Warfel farm, was being widened, another deposit of bones was dug up and summarily deposed of as before* [thrown in a neighboring ditch]. *Among the skeletons was one of a giant, side by side with a smaller one, probably that of his wife. The arm and leg bones of this Native American Goliath were about one-half longer than those of the tallest man among the laborers; the skull was immensely large; the lower jawbone easily slipped over the face and whiskers of a full faced man, and the teeth were in a perfect state of preservation.*

Today, all that remains to designate the Warfel farm area in east Erie is Warfel Avenue, a small street off Buffalo Road that was cut off and shortened by the building of the Bayfront Connector. The farm was located on 150 acres from Eighteenth to Twenty-eighth Streets and from East Avenue to Elm Street. John Elmer Reed's *History of Erie County, Pennsylvania,* written in 1925, tells of many Indian artifacts found in the area:

> *On the line of the P.&E.R.R., just beyond Warfeltown, in Erie, used to be a famous place for school children, and others, to search for skulls and other human remains. Many burial mounds were to be found thereabouts, which when disturbed yielded many a treasure as a reward for the efforts of the searchers. It is said a very large human skeleton was found there, and with two copper bowls which had been perforated around their edges and held together with a buckskin thong laced in and out of these perforations. The bowls held about a pint of beads each; but what has become of either bowls or beads, we have been unable to learn.*

Indeed, the giant bones have also disappeared, along with the artifacts found within the desecrated mounds. Along with the burial mounds that were scattered along the area of the railroad, which is now owned by Liberty Iron and Metal, there was a vast burial ground along the side of East Avenue from Twenty-fifth to Twenty-eighth Streets. Whereas excavators of the mounds found other Indian remains whose skulls were ceremonially flattened (which they called "flatheads"), the remains found alongside East Avenue seemed to have been unaltered. This led many experts of the day to claim that the remains found along East Avenue were of the Eries Indians, but the remains found in the mounds were of some older inhabitants of the area. The whole area around East Avenue and Buffalo Road was once a sacred burial site for generations of Native Americans.

East Erie was not the only place in the county where early settlers found burial mounds that contained skeletons of enormous size. Between Girard and Springfield, there was another burial mound that was excavated by farmers in the early nineteenth century. The exact location has been lost to history, but it has been told that an enormous human thighbone was found within that measured four inches longer than one of the workers, who stood at six feet, two inches. It was said in the early 1890s that a chain of four other mounds was spaced between Girard and East Springfield. They, too, have long since been desecrated, looted and lost to history.

West of Cranesville near Albion, John Pomeroy owned a farm that also had a burial mound on its land. Reed reported in his history of the county that "[i]t had a double enclosure upon which great forest trees of oak and other varieties were growing in the early part of the 19th century. The remains of a fire were found within it about 18 inches or so below the surface; while arrow heads, a huge skeleton, celts, and many other such like relics were found scattered about." Other reports stated that the skeleton found within measured over eight feet from head to toe. Again, the remains have since vanished, with no other report of their whereabouts.

Later in the nineteenth century, farmers in the southern part of the county were still finding curious artifacts in burial mounds. Warner and Beers's *History of Erie County* was published in 1884; it tells of other finds in the era that are even stranger than anything yet reported:

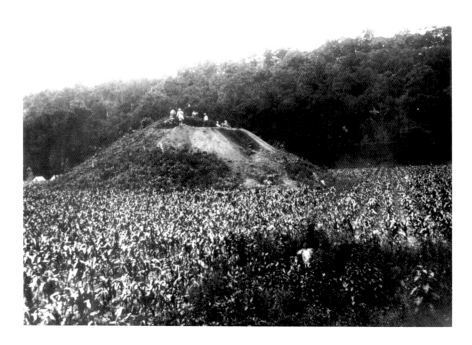

The Adena Mound of Ross County, Ohio, in 1901, before its destruction. Similar mounds were found by pioneers across Erie County and also destroyed. *Courtesy of the Ohio Historical Society Library Archives.*

> *Another skeleton was dug up in Conneaut Township a few years ago which was quite as remarkable in its dimensions. As in the other instance, a comparison was made with the largest man in the neighborhood, and the jawbone readily covered his face, while the lower bone of the leg was nearly a foot longer than the one with which it was measured, indicating that the man must have been eight to ten feet in height. The bones of a flathead were turned up in the same township some two years ago with a skull of unusual size. Relics of a former time have been gathered in that section by the pailful, and among other curiosities a brass watch was found that was as big as a common saucer.*

A gigantic brass watch as big as a saucer? What was going on here? Modern archaeologists claim that these tales were fabrication, part of the extravagant newspaper reporting in the late nineteenth century. Back in those days, just as in the tabloids in our time, tales of the fantastic tantalized the imagination of the reader and sold many a newspaper. It is true that tabloid journalism

is nothing new, but these reports were not reported in the newspapers of the time; they were reported in our local written history by men of repute and respect. People were finding strange things in the earth as they reformed the land to their needs. Before the European immigration, northwestern Pennsylvania was Indian land for many millennia.

Even downtown Erie was the scene of many ancient Indian burial sites. Writers for Warner and Beers mentioned that when the Erie and Pittsburgh Railroad was being constructed to connect to the Erie dock to the Lake Shore Road in the early nineteenth century, they ran into a massive Native American burial area near "the crossing of the public road and the rolling mill." The present-day area would be in the general vicinity of the four-way intersection of the East Bayfront Parkway, the East Bayfront Drive and Port Access Road. The bodies were of the "flatheads" type, whose foreheads were no more than an inch in width, and the remains were scattered as if there had been a great battle, with neither garments or implements in the area—common to a ritual burial. The workers who found the remains were superstitious and dumped the bones in a nearby ditch.

Giant bones were also found by those of important status in the early nineteenth century as people developed land for their own purposes. Although there is no record of it in the histories, Mercyhurst College archaeologist Allen Quinn recounted the legend of a giant skeleton found in a burial mound near the train tracks in North East Township. Reed's history makes mention of the mound, but there is no mention of giant remains:

A large mound near the New York Central R.R. tracks in North East Township, about three miles east of the borough of North East, was opened many years ago by Dr. Heard, a prominent physician and surgeon of that place, and several skeletons uncovered, all with feet pointing toward the center as in the spokes of a wheel. A number of stone relics were found, all

of which the doctor packed up and sent to an eastern medical school, we believe it was the University of Pennsylvania, at Philadelphia.

Other physicians also made discoveries of giant skeletons in the city of Erie. Warner and Beers's work again tells us that "[a]n ancient graveyard was discovered in 1820, on the land now known as Dr. Carter and Dr. Dickinson places in Erie, which created quite a sensation at the time. Dr. Albert Thayer dug up some of the bones, and all indicated a race of beings of immense size."

Again, there is no physical evidence of these discoveries. It is as if they have vanished into thin air. Or perhaps they never existed at all. According to the standard modern archaeological treatment of these historical records, scholars in our day will dismiss these findings as the fabrications that European settlers conjured up while moving into an unknown region in order to support their faith in biblical history—they are what they have been told are the authoritative facts according to modern scholarship in opposition to the naïve ideas of Christian settlers in our area who were more than ready to invent evidence to support their nineteenth-century biblical worldview. Giants are mentioned in the Bible several times, beginning with a primordial reference to giants inhabiting the earth long before civilization as we know it began with our human ancestors (in Genesis 6:1–4):

> *Now it came to pass, when men began to multiply on the face of the earth, and daughters were born to them, that the sons of God saw the daughters of men, that they were beautiful; and they took wives for themselves of all whom they chose. And the LORD said, "My Spirit shall not strive with man forever, for he is indeed flesh; yet his days shall be one hundred and twenty years." There were giants on the earth in those days, and also afterward, when the sons of God came in to the daughters of men and they bore children to them. Those were the mighty men who were of old, men of renown.*

The giants referred here are a translation of the Hebrew word "Nephilim," a past participle from the Hebrew root word "naphal" (to fall), and so the Nephilim are literally the "fallen ones." Some biblical scholars see the Nephilim as the offspring of fallen angels who became demonic entities after their bodies were destroyed in the Great Flood. Others, however, see the Nephilim as a reference to ancient kings from the long-lost past. What needs to be noted is that in all of the Erie histories there are no direct connections

with the skeletons found in the county to biblical giants. Most of the authors were very religious men; they even detailed the first communion to have taken place in Erie County and other obscure Christian trivia. But they did not connect these giant Native Americans with the Nephilim. They only made vague reference to them as coming from some unknown civilization that existed in our county before the Eries Indians located settlements here. In fact, they report these findings in a very matter-of-fact style, just as they do any other historical information known to many of the readers of their time. They reference specific places where the remains were found by specific people. Their reports have none of the sensationalism that one would expect if they were merely rehashing the tabloid tales of their time. They are objectively reporting the truth as they know it, and while they may reference "Goliath," it was as it is today (an idiom for giant); the writers make no direct connection of these ancient giants to a Nephilim "race" from the biblical past.

However, some recent paranormal writers do make the connection of these giant early Americans with the Nephilim. Steven Quayle, a frequent guest on George Noory's *Coast to Coast* AM radio program and self-proclaimed conspiracy theorist, sees these giants as a remnant of a fallen race of supernatural beings. On his website, he has a long list of similar findings of giant skeletons from all over the world; he has also recently written a book on the subject, *Genesis 6 Giants: Master Builders of Prehistoric and Ancient Civilizations*. Erie is certainly not the only locale where ancient burial sites have yielded gigantic human remains. The list is staggering. During the colonial era in the Great Lakes, Northeast and Midwest territories, whenever there were mounds, there were accounts of the discovery of giant Indian bones.

Ross Hamilton in his online article "Holocaust of Giants: The Great Smithsonian Cover-up" uncovers several incidents of giant bones found in or near local mounds in nineteenth-century Ohio. All of these incidents are documented in digests of local history. The main point of Mr. Hamilton's article is that the Smithsonian actively covered up the discoveries of giant bones in the nineteenth century in order to produce a preferred history of ancient America. In other words, the Smithsonian was a conspirator in nineteenth-century political correctness. He cites find after find of giant skeletons found in earthen mounds in our neighboring state of Ohio, as well as the documented dismay of other archaeologists at the representatives of the Smithsonian either destroying the evidence or confiscating it to be hidden away in its vast archives.

However, conspiracy theories might not hold the only reason why there is no longer evidence of these gigantic native remains. Conneaut, Ohio, was the home of many fantastic giant native discoveries in the nineteenth century. An 1844 edition of the *Geneva Times* contained an article of the history of Ashtabula County in which the author, Harvey Nettleton, reported of giant bones found in the city:

> *The mounds that were situated in the eastern part of what is now the village of Conneaut and the extensive burying ground near the Presbyterian Church, appear to have had no connection with the burying places of the Indians. They doubtless refer to a more remote period and are the relics of an extinct race, of whom the Indians had no knowledge. These mounds were of comparatively small size, and of the same general character of those that are widely scattered over the country. What is most remarkable concerning them is that among the quantity of human bones they contain, there are found specimens belonging to men of large stature, and who must have been nearly allied to a race of giants. Skulls were taken from these mounds, the cavities of which were of sufficient capacity to admit the head of an ordinary man, and jaw-bones that might be fitted on over the face with equal facility.*

Near the mounds were hundreds of other ancient graves:

> *The graves were distinguished by slight depressions in the surface of the earth disposed in straight rows, with the intervening spaces, or alleys, cover[ing] the whole area within the boundaries before specified, which was estimated to contain from two to three thousand graves. These depressions, on a thorough examination made by Esq. Aaron Wright, as early as 1800, were found invariably to contain human bones, blackened with time, which on exposure to the air soon crumbled to dust.*

Perhaps the bones of the giants, too, did not last long being exposed to the air after so many years. Indeed, there are reports that this is what happened to many of the remains that were found on farmland during the late nineteenth century.

Not every mound contained the gigantic remains of an unknown race. Most of then held normal native remains and the usual funerary items. Attributed to the Hopewell Indian culture, an unknown race of Native

The Wayne Township Mound off Route 8 in Lowville. *Photo by Robin S. Swope.*

Americans, these mounds litter the Northeast and Midwest. They vary in size from a small two-foot knoll to the hundred-foot Monks Mound in Collinsville, Illinois. Although most are forever lost, history attests that Erie County once contained a large number of the unique burial sites. Warner and Beers's work recounts the major ones that could still be observed in the late 1880s:

> *Equally curious are the pre-historic mounds and circles found in Wayne, Harborcreek, Conneaut, Girard, Springfield, LeBoef, Venango and Fairfield Townships. The principle one in Wayne Township, which is still in a fair state of preservation, is in the south branch of French Creek, near the road from Corry to Elgin…It consists of a vast circle of raised earth, surrounded by a trench, from which the earth was unquestionably dug, the whole enclosing about three acres of unbroken ground…Half a mile to the west, a little north of the road, on a slight eminence, was another and smaller circle, which has been plowed down, leaving no vestige behind.*
>
> *The circles in other portions of the county are or were similar in their general features, with one exception, to the above. Those in Harbor Creek Township were situated on each side of Four Mile Creek…on points overlooking and commanding the deep gulf of that stream.*

Of these, only the one in Wayne Township and the one on the west side of Four Mile Creek are known to remain in the twenty-first century. Both have been excavated and are much smaller than reported in the 1800s. The prominent one in Wayne Township is situated in a cornfield, and the current owner plows and plants on it every year; it can still be seen from the road as you drive on Route 8 just north of Wattsburg in Lowville. It now is only a slight bump on the landscape. The one on the west side of Four Mile Creek is located on the private property of a business and cannot be seen or accessed by the general public.

Who were these ancient giants of Erie County? Were they just genetic anomalies of gigantism who were members of the local community at the time? If that is so, Erie seemed to be the center for these genetic aberrations because the number of reported remains in our county far exceeds any other location currently known. Were they, as some claim, a separate race from the Native American population—a race of supernatural beings who had watched over mankind since the dawn of civilization? Or were they just the product of a vivid imagination, tall tales that took on a life of their own? There is an ancient Iroquois legend of a race called the Stone Giants; the Seneca name for them was the *Genonsgwa*, or "Flint Coat." They were gigantic people who wore clothing that was as tough as stone, making them impervious to bow and arrow or spear. One legend tells the tale of the great Indian warrior Skunniwundi fighting a female Stone Giant, who eventually yields to the hero. She then goes downriver and lives with a family of humans who help her fight off an abusive husband set out to kill her. The giant and her human allies were only successful in killing the male giant after the husband's stone armor was smashed during his conflict with his wife.

There is some archaeological evidence still remaining of the giants. In 1940, a giant skull and other large skeletal remains were found in an Indian mound in Victoria County, Texas. The *San Antonio Express* printed a photo of the skull, comparing it to other normal-sized skulls found in the mound as well. The paper claimed that it was the largest human skull found in the United States and possibly the world. The remains were dated to be between forty thousand and forty-five thousand years old.

Scripture tells us that "[t]here were giants on the earth in those days." It would seem that many of them lived and were laid to rest right here in Erie County.

THE LOST GRAVEYARDS OF ERIE

It is said to happen a few times each week. Someone approaches the librarians manning the information desk at the Blasco Memorial Library with a bit of obvious nervous trepidation. They want information on past homeowners or the history of the land of a certain residence in the city. The library does not have such reference material, and they are often sent off to the Erie Courthouse to see if, by chance, any records can help them. Often it is fruitless. When asked what type of material they are looking for in the records, the person often says with hesitance, "a murder or a death that happened in my home." When pressed further, they will finally get to the reason for their search: their home is haunted. They hope that in a search for the background of their home they can find out why these things are happening. Of course, such a search is not a quick and easy one; often it leads to dead ends. Deaths, be they from natural causes or foul play, are never recorded in property records. You would have to spend many hours digging through an overwhelming number of newspapers to make a connection.

Perhaps the answer to many of these people's questions does not lie in a tragedy that occurred on their property. Perhaps their homes have been built on a long-forgotten burial ground. Since the time of ancient Greece, western culture has held the notion that one who is improperly buried or whose burial grounds have been disturbed will come back to haunt the living. Erie, having evolved from a pioneer town, has its share of lost and forgotten graveyards. Many of these were communal cemeteries established by local churches, and the congregation has moved on or ceased to exist. Others were small, family burial plots on private property or farmland. Many Indian burial grounds were found across the county as European settlers turned the wilderness into homesteads. The remains that they found were either discarded without dignity or ceremony or kept as odd souvenirs.

Even when an old graveyard from Erie's beginning was clearly marked, most of the dead were buried in wooden caskets that quickly rotted in the wet soil. When graveyards were moved, those who disinterred the bodies could find little or nothing to relocate. At other times, the graves were poorly marked or the families of the dead could not afford a marker. Even with written records, a body could not be located, and the workers moved on.

Erie County is riddled with lost and forgotten burial grounds, many unknowingly desecrated by urban expansion and suburban development.

An abandoned church graveyard in Greene Township. *Photo by Robin S. Swope.*

Does something go bump in the night at your home? It may be the restless dead. Combing through local records gives a clue as to the location of some of the major lost burial sites in Erie. Following are several such sites.

The OLD FRENCH GRAVEYARD was situated west of lower Parade Street near the site of the French fort Presque Isle. A small community of about two hundred French families had sprung up around the fort. A small cemetery, along with a tiny chapel, was founded in 1753 to accommodate the first western settler to die in the region, Jean Baptiste Texier. The graveyard and community were abandoned when the French retreated from the area. All buildings along with the fort were burned to the ground after the British victory at the Battle of Fort Niagara in 1759. The graves, as well as most of the names of the early French colonists who were buried there, are lost to history.

The burials along FRENCH PORTAGE ROAD truly represented a graveyard without boundaries. Hundreds of French soldiers and laborers were buried in shallow graves alongside this road when overcome by fatigue or

disease. The makeshift graves at best had temporary wooden crosses to mark the burial. Those crosses are now gone, and all along Route 97 and the southern end of Route 19 there are literally hundreds of old French burial sites.

The RUTLEDGE BURIAL GROUND: In what is now a dark alleyway just behind the behind the building that houses the Perseus House is the location for one of the oldest English burials in the city of Erie. It is also the first burial ground said to be haunted. John Elmer Reed's *History of Erie County, Pennsylvania* gives an account of the details:

> *Just before the arrival of the surveyors in June 1795, occurred a most distressing event at or very near to where the present Central Market house now stands, being just south of the present State Street Bridge of the New York Central Railroad in Erie. This was the attack upon Ralph Rutledge and his son, with two other men, on May 22 1795, resulting in the killing of Ralph Rutledge, and the mortal wounding of his son. The fate of the other two was not learned. The younger Rutledge was found and carried to Fort LeBoeuf, where he was tenderly cared for; but his wounds and the scalping which he suffered, shortly terminated in his death. His father was buried near where he was found. This spot was for many years supposed to be haunted, and many a person walked a wide detour around the place, especially after dark, rather than venture to withstand the mental terrors accompanying a trip past it. It was currently reported at the time that the deed was caused by Indians, and caused considerable correspondence between the commandant here, the Governor, and the Secretary of War. The death of Ralph Rutledge is the first known death of an Englishman, or American, in this county, after those who suffered in the destruction of the forts.*

The 1801 ERIETOWN GRAVEYARD: In Erie's early days, the city was called "Erietown." Like the French before, many of the English settled near Mill Creek. After its incorporation as a borough on March 29, 1805, and the Act of 1833 that fixed its boundaries, the name "Erietown" gave way to the official title of "Borough of Erie." This graveyard was located at the mouth of Mill Creek. Bodies were buried there until 1805, when it was abandoned.

The TULIO ARENA GRAVEYARD: In 1805, three lots were set aside for burial at the southeast corner of Eighth and French Streets. The entire community

used it until 1827, when the graveyard and lots were taken over by the United Presbyterian Church. It was once again sold in 1862, and the bodies were reinterred at the Erie Cemetery on Twenty-sixth Street. There were rumors about the community by those who claimed that the many unmarked graves remained in the lots even after the business district moved into the site. The Tulio Arena was opened on the site in 1983.

The *NIAGARA* DESERTER'S BURIAL GROUND: In the spring of 1813, while the *Niagara* was docked at Misery Bay, James Bird, John Rankin and John Davis were tried and convicted in a military court-martial on the charge of desertion. They were executed, and their bodies were buried on the sand beach east of the mouth of Mill Creek. The area is now home to Lampe Marina and the Lampe Campground.

The LOST CHURCH GRAVEYARDS: The First Presbyterian Church bought four acres for a cemetery in 1826 that they used until 1851; it was situated on the South East corner of Seventh and Myrtle, across from the church. The bodies were moved to Erie Cemetery when it was opened in 1851, and the land was sold. It is now a parking lot. An Episcopal graveyard was established on the west side of Eighth and Myrtle Streets in 1827. It, too, was abandoned in 1851, and the bodies they could find were moved to the new Erie Cemetery. Currently, a pizza restaurant is located at the site.

St. John's Lutheran Church established a graveyard in the square behind its church between Twenty-second and Twenty-third on Sassafras Street in 1836. The deed for the property from Conrad Brown stipulated that the property be used for a graveyard. After it was abandoned in 1851 and what remains could be found were reburied at Erie Cemetery, only two or three graves were left in the center of the square so that the deed stipulations could be met. The land is now home to the Village at Luther Square retirement home and its staff parking lot. St. Paul's United Evangelical Church bought two acres of land on the corner of Twenty-sixth and Cherry from J. Berst for a cemetery, and it was dedicated on August 14, 1859. It was sold again to the school board on December 6, 1891. Remains that could be found were moved to Erie Cemetery. This area is now residential.

Whereas most of the city's Protestant graveyards were abandoned in 1851 when the Erie Cemetery was established; the Catholics in Erie started to rebury their dead in Trinity Cemetery on West Lake Road after it was consecrated in 1869. However, many of their graveyards had

been abandoned before Trinity was established. The old St. Patrick's Church started a graveyard in a small site near its church on Third Street between German and Parade Streets. Members found that it was too small and abandoned it in 1850. It is now residential property. In 1850, they moved the bodies of their dead to a new five-acre tract of land at the corner of Twenty-fourth and Myrtle. Once again they abandoned this graveyard when Trinity was established in 1869, and they moved many bodies for the second time. The grounds of this second graveyard are now occupied by Saint Vincent's Hospital. In 1837, St. Mary's Catholic Church purchased ground at Ninth and German, where members built their church, St. Benedicts Convent and Academy (now St. Benedicts Education Center and the GECAC Head Start Center) and a graveyard that was consecrated in 1839. They abandoned it in 1852, and the grounds are now a children's playground.

Most of the city's churches moved their dead to the newly formed cemetery associations in the mid-1800s. But that was not so with many churches that were located in the city's suburban areas. One of the first churches built in the suburban county was a pioneer log cabin church at the mouth of Walnut Creek that was constructed about 1809. Along with the church, the foundling congregation consecrated a few acres to bury their dead. It was called by locals the Fairview cemetery (not to be confused with the cemetery by the same name that is on Maple Street in the center of the township that was consecrated in 1879) and was later abandoned along with the church building. The site now is the Walnut Creek fish hatchery at the foot of Manchester Road. The bodies were never relocated.

Asbury United Methodist Church once stood on a small patch of land off Millfair Road west of Swanville. The small meetinghouse was abandoned in the 1840s, along with its fledgling graveyard. What bodies that could be found were transferred to the church's new location on the corner of Asbury and Twenty-sixth Streets. If you search diligently, you can still find what remains of the church's crumbling foundation in the woodlands off Millfair Road, just south of West Thirty-eighth Street.

The ERIE COUNTY ALMSHOUSE CEMETERY: One of the oddest and most disturbing tales of abandoned cemeteries in Erie County has to do with the old Erie County Almshouse Cemetery. From 1871 to 1918, the county almshouse stood on one hundred acres of farmland bordered

by Pittsburgh Avenue to the east, West Twenty-sixth Street to the south and West Twenty-first Street to the north. It was home to the poor and destitute who had no means to support themselves. It also was a home for the aging. During this time, 690 people were buried in the cemetery that lay along Pittsburgh Avenue. In 1977, bodies were removed and reburied in what is now called the Old Alms House Cemetery on the Dobler Farm off Blair Road in Fairview Township. The memorial marker at the current site tells the story of the almshouse and the removal of some of the remains:

Within the confines of this cemetery lie more than 1500 of Erie County's sons and daughters dating back to Thomas Jefferson's Presidency. What stories they could tell! Those buried here came from all walks of life, from all races, and from many different religions. They were as different from one another as are the enumerable snowflakes yet when they passed away—from natural and unnatural causes—they shared one common fate: they each left the earth as penniless paupers. We will probably never know the details of their lives. But we do not know that most were either occupants of the old Alms House (poorshouse) once located at West 23rd and Pittsburgh Ave. or their bodies were sent here when officials could not find next of kin. His pauper's cemetery or Potter's Field as it has been known, was not so kindly-remembered or so cherished as it is today. In the mid-1800s, bodies from the poorhouse—many of them infants or young children—were buried in unmarked graves in the old Alms House Cemetery. The practice continued until Dec. 2, 1920 when a 72-year old man became the 690th person to be buried at the Alms House. The next Alms House death, a 61-year old man was buried at Dobler Farm—the present location of this cemetery in Fairview Township. Over the years, the original Potter's Field was originally forgotten. But in 1977, when and Industrial Park was proposed for the area, The Erie Morning News using an old county map discovered the construction would intrude upon and disturb the graves of 690 long forgotten paupers. As a result Erie County Coroner Merle Wood, working with a dowser or diviner, unearthed the remains of 443 people. The remaining of another 247 souls, buried under utility lines and roadways, were left behind by court order on Sept 7, 1977. Seven vaults containing the remains of the 443 were interred here at

the Dobler Farm Cemetery on the Blair Road with appropriate religious services. Exact identities of the 443, as well as the 247 left behind will never be known. The names of those buried here since 1921 have been recorded in the Alms House record book. This property, owned by the County of Erie, was given only minimal maintenance until August 1991 when another Morning News series on the potter's field triggered County Government into taking a compassionate look at the cemetery. A committee composed of county officials, political, business and civic leaders and administrators from nearby Pleasant Ridge Manor meeting monthly to create a formal cemetery, one that would become a dignified final resting place for those buried here for all time.

About 250 of the almshouse residents still remain buried under the end of West Twenty-third Street and Pittsburgh Avenue. Many are under businesses

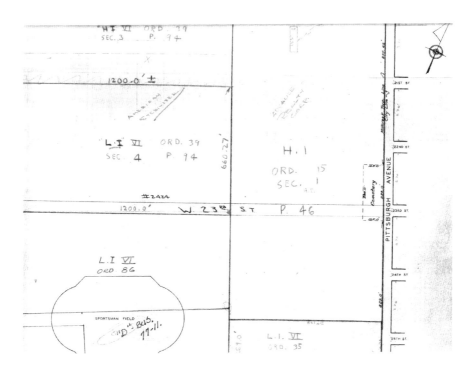

Millcreek Township Engineering Map showing the location of the old Erie Almshouse cemetery. Courtesy of Millcreek Township.

and the roads themselves. When Twenty-third Street was extended, skulls and other body parts lined the side of the road of what is now the end of Twenty-third. There were reports of looters trying to take some of the remains for grisly trophies. So the next time you drive down Pittsburgh Avenue and stop at the light on Twenty-third Street, look around and remember the poor unknown destitute souls buried here. Say a prayer; you are in the middle of a graveyard.

INDIAN GRAVEYARDS: The corner of Twenty-third and Cascade was revealed to be a burial area when housing was put in during the late 1920s. There was an Indian burial ground on the northeast corner of Buffalo Road and Water Street until it was ploughed over in the late nineteenth century to make room for commercial buildings. It is now home to a Dollar Tree store. East Avenue's east side, from Twenty-fifth to Twenty-eighth Street, was the site of a massive Indian burial area that was looted by local curiosity seekers and children throughout the late nineteenth century. On the old Scoullier farm, which lay south of Twenty-eighth Street between Elm and Avenue—directly south of the Martin Warfel farm—there was a large Indian burial graveyard with many mounds.

In the early nineteenth century, Indian parties would customarily visit these grounds and camp nearby so that they could perform commemorative rites at the grave sites. The last rite took place in June 1841 when a dozen Indians spent a few days performing ceremonies at the site. Within a decade after that, the mounds were desecrated and looted regularly by young settler boys; by the 1880s, the mounds had been plowed down, and no traces existed of the once sacred burial ground. On old Ridge Road east of the city, burial grounds covered the area from the old Ebersole farm to State Street. Old Ridge Road is now known as East Twenty-sixth Street. A large burial area that contained hundreds of bodies was also found by railroad workers as they lay the tracks that now cross East Sixth Street and the Bayfront Parkway; the remains were tossed into a nearby ditch. Many early farmers in Waterford recount that traveling Indians would often visit their land to honor the dead in graveyards that were turned into farmland. There are undoubtedly many more small family or communal graveyards that have faded into the mists of history.

There are multicultural taboos about desecrating graveyards. The Native Americans had them, as did the Europeans. But there seems to be something about the early settlers to Erie County—not only did they

have no problem with desecrating Indian graves, they also had no problem building on the former and present land that was consecrated for the burial of the pioneers themselves.

Events in movies such as *Poltergeist* echo our phobias of living on burial lands. There is an old theory that abandoned and desecrated graveyards are portals to another realm—a place from beyond where echoes from the past manifest themselves in various ways. Erie has an abnormally high number of hauntings that deal with "shadow people," phantoms that look like animated shadows of humans and that sometimes flit on the periphery of vision. Many accounts show them to be maniacal tormentors of the living, impressing fear and mental anguish on their victims. Could they be the forgotten dead whose desecrated graves now accommodate modern homes?

THE LAKE ERIE STORM HAG

Since first explored in the 1600s, the Great Lakes have earned a reputation as being treacherous and unforgiving waterways. Extremely violent storms seem to appear out of nowhere, taking both vessel and crew to a watery grave.

In 1977, author Jay Gourley's *The Great Lakes Triangle* proposed that there were some sinister forces behind all of these mysterious disappearances. However, many sailors on Lake Erie, at least, have had a theory for centuries on the unexplainable storms and the shipwrecks that plague the freshwater lake: the Storm Hag.

According to legend, the Storm Hag lives at the bottom of the lake, close to Presque Isle Peninsula. She is a hideous "she demon"; her yellow eyes shine in the dark like those of a cat, and her skin is a pale shade green. Her teeth are as sharp and pointed as a shark's, able to tear the skin off her victims. They are also green, which gives her another less common name: Jenny Greenteeth. Her hands have long, pointed nails like talons—they have a poison that can paralyze a poor soul with just one small prick. Her arms

are long and strong, and they wrap around her victims, making it impossible for them to escape her flesh-hungry attack.

The old legend tells that, like a siren, before she attacks she sings a quiet song over the waves that few have survived to retell:

> *Come into the water, love,*
> *Dance beneath the waves,*
> *Where dwell the bones of sailor lads*
> *Inside my saffron caves.*

As soon as the seafarer hears this song, the Storm Hag attacks. She calls up a violent storm that tosses the crew of the vessel around so she can lurch up from the water and grab them with her long arms. Others tell that she waits the storm out—when the sailors believe all is calm she rises from the waves, spitting lightning and winds with such force the entire vessel sinks in a few seconds.

Local history has it that on a fall evening in 1782 an owler ship was caught in a bad storm on the lake and desperately tried to make it back to port at Presque Isle. It was tossed to and fro violently for more than an hour, and when it was in sight of land the storm abruptly stopped. The clouds dissipated, the light from the full moon illuminated the water and the sailors could see that they were less than a mile from the northern edge of the peninsula and home. Without warning, the water next to the boat foamed, and the Storm Hag burst forth from the surface. She spewed venom and attacked the crew, unleashing her fury upon them. Within seconds, the ship and its crew were taken beneath the waves to their doom. Witnesses onshore apparently heard the screams of the sailors echoing across the lake just before the vessel disappeared. To this day, some of those who sail the lake near Presque Isle claim to hear phantom screams of the victims who were taken long ago.

Now these legends seem the work of overly imaginative sailors until one looks at some very disturbing incidents documented within the last 150 years. On December 1942, the oil tanker *Clevco* was being escorted with towline by the tugboat *Admiral*. They had left port at Toledo and were traveling east when, just off the coast of Cleveland, something strange happened. At 4:00 a.m., the *Clevco* radioed that the *Admiral* had disappeared without incident. The crew noted that the towline was no longer attached to the tugboat but

that it was set at a sharp angle into the waves, as if the tugboat had somehow sunk to the bottom of the lake without a sound. The *Clevco* immediately stopped and radioed the Coast Guard; two cutters and a few motorboats were dispatched to the coordinates. However, upon arriving at the scene, they found nothing. Both ships had vanished.

The next morning, the Civil Air Patrol joined the search, and pilot Clara Livingston spotted the *Clevco* fifteen miles south from its original location. As soon as she reported the location to the Coast Guard, her radio went dead, and she saw the ship disappear as a cloud of snow fell upon it from out of nowhere. Since her radio had died, she returned to base. The Coast Guard again went to the location and found nothing. Crews widened the search and the hunt continued. Strangely, later in the day the cutter *Ossipee* spotted the tanker; when almost in range to board it, once again the snowstorm phenomenon appeared, and the vessel once again disappeared. Then, at 3:30 p.m., amazingly, the *Clevco* once again acquired radio contact with the Coast Guard. The crew reported that the ship was adrift and that they were unable to steer it. While in contact with them for more than an hour, the authorities told them to dump their oil so that the rescuers could more readily find them. But at 4:30 p.m., the contact with the *Clevco* ceased, and it was never heard from nor seen again. Early the next morning, bodies of two *Clevco* crew members washed ashore near Cleveland, their lifejackets covered in oil. No other crew members were found, living or dead.

Just as disturbing are the phantom burning ships that used to appear off the coast near the city of Erie in the mid-1800s. It was an odd phenomena that occurred every fall for many years. In November 1867, a now defunct early newspaper, the *Erie Dispatch*, reported how every autumn coastal residents and sailors would see a ship burning in the distance. When an attempted rescue was made, the ship would simply vanish into the horizon. The *Dispatch* noted that the most recent occurrence had happened on October 29 at about 7:00 p.m.; when sailors went out to the burning wreck, they found that it did not move, even though the wind was strong that night. It simply disappeared before their eyes.

Some at the time claimed that it was the phantom image of the steamship *Erie*, which caught fire and burned off Silver Creek in 1841. On 8:00 p.m. on the Monday night of August 10, 1841, the steamship *Erie* was thirty-three miles from the city of Buffalo when there was a massive explosion

on board. The ship carried a large cargo of turpentine and was consumed within minutes, leaving 250 people dead. Years later, on November 24, 1862, a phantom ship that looked exactly like the steamship *Erie* was seen burning off the Erie coast for more than two hours. The ship appeared to be more than two hundred feet long, and flames were spiraling from port to starboard, lighting the night sky and shooting sparks and debris into the air. Onlookers were expecting survivors to row to shore from the wreckage, but none ever came. A storm began to build, and as the clouds gathered in the distance, gradually the phantom ship slowly faded into thin air, still ablaze. Even national journals noted the phenomenon, the *Scientific American* from August 8, 1860, reporting of a phantom burning ship off the shores of Cleveland after an intense thunderstorm. Veteran sailors warned all not to venture forth and mount a rescue because it was a ghostly ruse to lure the rescuers to their deaths. Were these phantom ships a trick of the Storm Hag to lure others to a watery grave?

Then there is the mysterious disappearance of Captain George Donner. In April 1937, the freighter *O.M. McFarland* left Presque Isle for Port Washington, Wisconsin. The captain retired to his cabin for the evening and instructed the first mate to notify him when they were nearing their destination. According to the *Cleveland Press* of April 29, 1937:

> *At 1:15 a.m. (April 29, 1937—J.T.) as the McFarland neared Port Washington, the mate, as instructed, descended to the captain's room to summon him. There was no response to his knocking on the door, so the second officer opened it and peered in, assuming that the captain was merely sleeping heavily. But Captain Donner was not in the bed or anywhere else in sight.*
>
> *…On the possibility that the captain had walked aft to get coffee or partake of the night lunch, the mate hurried back to the galley, but except for a couple of off-duty firemen finishing a midnight snack, it was deserted. Quickly summoning the other mate and the chief engineer, he organized a thorough search of the McFarland, crew members combing every nook and cranny of the thirty-four year-old vessel. Without a doubt, Captain Donner had disappeared!…Ships along the McFarland's route were asked to keep a watch for Donner's body, and the same request was passed on to communities along the shore.*

Captain Donner's body was never found; it was as if he had been snatched off the face of the earth. Was Donner a victim of the Storm Hag? His disappearance does fit the tradition of the legend.

The Storm Hag seems to have a cohort in a mysterious phantom Black Dog. The legend of the dog actually can be traced back to an actual tragedy that happened long ago. James Donahue, Great Lakes history expert, tells the story of the senseless killing of a pet mascot that fell overboard and got crushed while the vessel was locking through the Welland Canal, between Lakes Erie and Ontario. The dog was a large black Newfoundland. Newfoundlands are a huge breed of dog; some can grow to the size of a small bear. They have webbed toes and were bred as water rescue animals, thus making them expert swimmers. They were brought by Vikings to Newfoundland, became popular during the eighteenth century as ship dogs and were often used to carry lifelines to sinking ships. The legend tells that the dog had jumped into the water and was swimming alongside of the ship as it entered the lock. The sailors made fun of it as it began to have difficulty and began to slip under the water. Instead of attempting to help the dog, the sailors taunted it, and the animal was crushed in the gate of the lock. The ship became stuck when the dog's corpse interfered with the lock's mechanism, so the sailors had to wait as lock workers dislodged the corpse and got the gate working again. That night, as the crew sailed Lake Erie, they were haunted by the howling of a phantom dog. Ever since then, whenever the Black Dog of Lake Erie has appeared, a major shipwreck followed.

Is there a demonic entity that lurks at the bottom of Lake Erie near Presque Isle that takes the unwary navigator to his death? Surely the number of shipwrecks on the lake within recorded history gives one pause. Are they victims of odd meteorological phenomena or a sinister paranormal entity that holds sway over the area? With phantom ships and phantom dogs along with the weird weather that can take a ship down in minutes, one cannot but concede that something powerful and deadly is at work on Lake Erie.

LAKE ERIE'S GHOST SHIP

December 7 has been etched into the American consciousness as one of the deadliest days in its maritime history. On December 7, 1941, the Japanese struck the American naval fleet in Pearl Harbor, an attack that sent both nations headlong into a bloody and culturally changing conflict. There was another maritime tragedy that took place on the same date some thirty-two years earlier.

On December 7, 1909, at 11:00 a.m., the *Marquette & Bessemer No. 2*, a 350-foot-long steel-hulled car ferry, left the port of Conneaut, Ohio, with a cargo of rail cars filled to the brim with coal. The heavily laden ship headed north, bound for Port Stanley, Ontario. A notable passenger on board the *Marquette & Bessemer No. 2* was Albert Weis of Erie, the treasurer of the Keystone Fish Company. Weis carried $32,000 in a leather briefcase in order to purchase a Port Stanley fishery for his employers at Keystone.

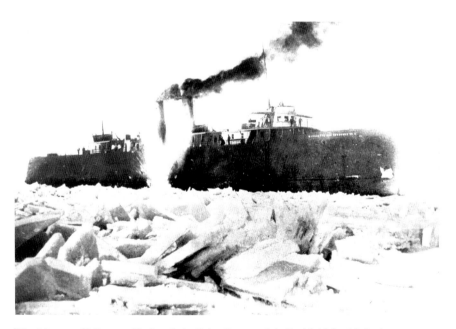

The *Marquette & Bessemer No. 2* on Lake Erie. *Courtesy of the Patrick McLeod Collection.*

Lake Erie has a long history of being one of the most treacherous of the Great Lakes, with powerful storms seeming to appear out of nowhere. And as the *Marquette & Bessemer No. 2* made its way north away from the shores of Ohio, there was a great storm brewing on the horizon. The blistery winter storm suddenly blew out of the west and slammed mightily onto the Great Lakes, with winds that were estimated to have reached at least ninety miles per hour. The storm's might was so furious that it actually dropped the temperature forty-five degrees within a twenty-four-hour time period.

Battered to and fro, the *Marquette & Bessemer No. 2* tried in vain to crisscross the lake in a doomed attempt to ride out the storm. The fierce and frigid assault of the storm, mixed with an unfortunate streak of bad luck, sealed the fate of the ship and its thirty-one passengers and crew. The ship, its cargo and crew went to their watery graves in the deep depths of Lake Erie on the evening of December 9, 1909. Last reported accounts tell that the ship was seen struggling in the waves off Port Stanley and that it seemed to have turned west. It was never seen again. Legend has it that about the time the ship went down, the captain's wife, who was on the southern coast of Lake Erie at Conneaut that night, heard the mournful, pathetic blow of the ship's whistle as it sank beneath the waves.

Three days later, on December 12, a lone lifeboat was found ashore fifteen miles from the city of Erie, Pennsylvania. It contained the frozen bodies of nine of the crew and one ice-encrusted set of clothing from a tenth in a position that seemed to show that whoever had donned the clothing had simply disappeared. The belt was tied, the shirt was tucked into the pants and a coat covered it all in perfect order. To complete the hallow façade of frozen terror; the shoes still had their socks stuck to the inside as if the wearer had filled them when they froze.

Despite the great length of the ship and the shallow depths where it was supposed to have sunk, the wreck of the *Marquette & Bessemer No. 2* has never been found. At more than one hundred meters, the ship was as long as a football field. Few such large ships have eluded devout hunters of sunken ships along the Great Lakes. Despite thousands of dollars by private entrepreneurs and scientists, and hour upon hours of diving expeditions, the site of the ship's resting place has never been found. Indeed, it seems as if the ship was destined to be lost.

According to the *Erie Times News* of December 7, 2009, on December 4, 1909, Sarah Clancy of Erie—whose brother, John, served as watchman

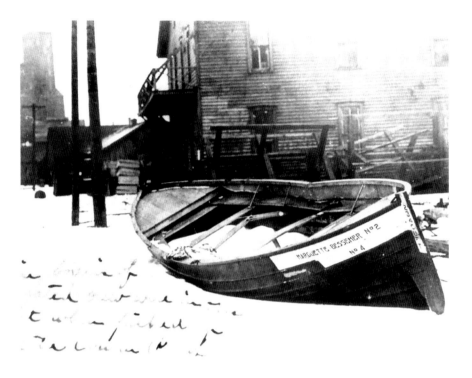

Lifeboat no. 4 after it was towed into Erie Harbor on December 12, 1909. *Courtesy of the Patrick McLeod Collection.*

on the ship—had a prophetic dream. Sarah dreamed of a great storm, and she saw a ship sinking beneath the violent waves. In the midst of the chaos, Sarah heard the voice of her brother, John Clancy, calling out to her. She awoke and was sure that the *Marquette & Bessemer No. 2* was about to face an imminent disaster. But when she told her sisters of the dream, they laughed and made fun of her superstitious nature. Her fears were realized when a tugboat hauled in the lifeboat with the nine dead bodies into Erie's harbor. "John is lost," Sarah mournfully told a *Times News* reporter at the scene. "My horrible dream has come true." On September 1910, a body was found that had shoes that matched a pair that Sarah had bought for her brother before he left on that fateful day in December. Although it could not be officially identified, Sarah knew that it was her brother.

The horrible storm on lake Erie that December 7 took more than just this one ship. The December 11 *Erie Times* reported that the storm had claimed

four boats and fifty-nine lives. Unlike the other three vessels lost that night, the *Marquette & Bessemer No. 2* lives on, not just in the memory of the lost crew's loved ones, but in the realm of the unexplained as well. It seems that since it sank below the icy waves of Lake Erie on that dark December night more than one hundred years ago, the *Marquette & Bessemer No. 2* has been seen and heard on multiple occasions.

Many times since its untimely demise, sailors have heard the ghostly moaning whistle of the ship when theirs is the only vessel for miles around— an old-fashioned whistle that seems to struggle in a mournful wail that bemoans its fate. It was likely much the same kind of sound the captain's wife reportedly heard that December night as the ship gave into the struggle with the pounding waves.

It also seems to be a common occurrence all across the beachfront of Lake Erie in both Pennsylvania and Ohio for a phantom ship to appear on the horizon just for a few minutes before it fades away into a haze. Ore carriers are still a common sight on most of Lake Erie, and it is not unusual to see them slowly crawl across the horizon as you relax on a Lake Erie beach during a hot summer day. But no ore carrier today has that old configuration nor belches dark smoke from two forward smokestacks. And none of them just fades away into the horizon. The usual beachgoer may be too caught up to take much notice, but I have heard on more than one occasion where someone was taking in the panorama of Lake Erie and spied a distant ship in the shape of the *Marquette & Bessemer No. 2* just blink out of existence. Now these, of course, could just be visual tricks or hallucinations, but James Donahue related in his article "Ghost Ship Marquette & Bessemer No. 2" that "[a]dding to the mystery is that the wreck has reportedly been seen from the air on clear days. It has been sighted about eight miles northeast of Conneaut, in about 10 fathoms of water. Yet no one has located it by boat."

To this day, divers of the Great Lakes covet to find the mystery wreck of the *Marquette & Bessemer No. 2*. It has often been hailed as the "Mount Everest of Great Lake shipwrecks." But perhaps all these divers and researchers have to do to find the old ship is to sail out in a dark, lonely night and wait to hear the mournful wail of the whistle to echo across the lake's surface. And if they hear it, perhaps they can track it down to its source. Will they find the old *No. 2*? Or will they find their own chilling fate?

THE FORGOTTEN DEAD OF GRAVEYARD POND

Erie has a rich history. One of the finest treasures restored to its old glory from days gone by is the flagship *Niagara*, the ship that won the Battle of Lake Erie, the decisive naval victory for the fledgling United states Navy over the prestigious Royal Navy of Great Britain. It was a major turning point in the War of 1812. It showed the world that our tiny newly founded country was indeed a force to be reckoned with. However, there is a legend that haunts the ship, a legend of the horrible fate that befell some of the noble veterans of the Battle of Lake Erie.

It was the winter of 1813; after a brilliant naval victory by Commodore Oliver Hazard Perry in September that secured the strategic waters of Lake Erie for the American forces, Perry's flagship the *Niagara* weathered out the harsh winter at Presque Isle's Little Bay. But fate would turn the safe harbor of Little Bay into what we would know today as Misery Bay.

Smallpox had begun to spread on board the *Niagara*. But being quarantined in the bottom of ship's hold did little to stem the tide of the disease, and the plague was quickly spreading throughout the ship. When those of the crew were struck down with the disease, officers ordered that their bodies be buried at sea in the lagoons of the pond near the bay. They would make their way across the ice to the nearby but still remote pond and chip a hole in the ice. The bodies of the dead were already prepared, wrapped in spare canvas that was stored for repairing the sail. A cannonball would be placed on their chest, and then they were sewn up into a secure canvas coffin. The cannonball would sink the body to the lagoon's bottom and prevent it from rising as the cadaver decayed and gasses from the rotting flesh would try to make the corpse float to the surface. As the plague's ferocious force began to unleash itself upon all the crew, those in charge made a radical decision to bury all of the dying who were infected with disease at the bottom of the adjacent pond. There was little hope for them—the officers did what they had to do in a frontier region of what was then a remote wilderness with little hope that help would be coming for a long time. They buried the dying, who yet had the tiniest breath of life, in the little pond; they surrendered them beneath the waves before death had the chance to naturally take their lives.

It was a harsh but relatively quick death. Some saw them as mercy killings. Others saw them as abominable acts that had no vindication. It was done to

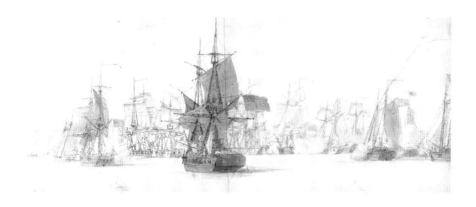

Perry's Victory, by Thomas Birch, circa. 1814. *Courtesy of the Library of Congress.*

stem the tide of disease that was claiming the lives of the living sailors who were needed in future battles. But the war was over within a year.

When England and America were no longer at war, both the *Niagara* and the *Lawrence* (Perry's initial flagship that was abandoned due to heavy damage during the Battle of Lake Erie) were sunk into the depths of Misery Bay. The *Lawrence* was raised in 1875 for the 1876 Centennial Exposition but would later be consumed in a fiery fate later that year. The *Niagara* was raised in 1913, and the portions that were restorable were placed on display at the port of Erie until 1995, when a fully restored *Niagara* once again sailed the tempestuous lake on which it gained its renown for securing early American sovereignty.

On the other hand, the forgotten dead who forged the fate of a newly born America yet wait to be raised at the last day. Their untimely fate in the bottom of that small pond gave the lagoon a new name: Graveyard Pond. According to this legend, what should be a nationally honored graveyard for the veterans of the Battle of 1812 has instead become a forlorn site, abandoned by time and forgotten by those who bathe in the rewards that were bought by sweat, blood and bone. The dishonored dead throughout the centuries past have made themselves manifest so that those in the present do not forget their sacrifices and the horrid fates they earned in the service of their country.

It is not easy getting firsthand witnesses of the ghosts of Graveyard Pond. The pond is situated in Presque Isle State Park, and visitors are only allowed to drive the roads after dark, but they are not allowed to park after dark. As

it is in so many haunted locations, the dead only seem to manifest in the dark. So most who might witness any activity are in moving vehicles, since Graveyard Pond is situated by a bridge and off the road by as much as sixty yards in heavy brush in most places.

In a bustling town with many teenagers, make-out spots abound, and the peninsula of Presque Isle is the frequent site of many a teenage rendezvous on the beaches or by the shore, as well as, it seems, of many an encounter with the unexplained.

Ted's teenage days are long gone, having faded with the ducktail haircut and the poodle skirts of the 1950s. Now in his seventies, he still remembers his wild days of youth and the many romantic encounters he shared with beautiful young girls at Presque Isle after dark. He also remembers a frightening encounter near the Perry Monument one summer evening in 1956. He and his date had ridden their bicycles into the park just before dusk and sat hidden on the shoreline of Misery Bay for a few hours, cuddling and enjoying the lights of the city from a distance. He doesn't remember the exact time, but it was soon after the evening fog rolled in from the bay that they felt as if they were being watched. The fog billowed in rolling waves and inundated the entire area, leaving a blanket of haze about three feet above the ground. Nervous and feeling eyes upon them, they looked to and fro as they got up and made their way to their bikes.

Inside the mist across the road, something began to move. Thinking that it was a park officer, and not wanting to be caught in the park after hours, they quickly hid themselves behind the brush. What they saw before them was very odd, in Ted's own words. The mist seemed to coagulate into a solid form—the dark shape of a man dressed in old, torn clothes. He slowly walked in their general direction but did not seem to be aware of them until he was almost in the center of the road, whereupon the man quickly turned in their direction, made a muffled, moaning sound…and then disappeared.

So did Ted and his lady friend, once they regained their wits, and not only did Ted never again woo a young lady at that same site, but he also regretfully told me that he was never able to get that same girl on another date again.

The claims of the specters of the dead and dying who found their graves in the cold waters of Cemetery Pond have been whispered about Erie, Pennsylvania, for more than one hundred years. There are stories that Joe

Root, the hermit and squatter of Presque Isle in the late nineteenth century, often saw some phenomena around the pond that he called "Perry's Will O Wisps"; he thought that they were the spirits of the dead sailors buried beneath the water, coming back to roam the land and looking for revenge on the living for abandoning them there before their time. It seems that the phantom phenomenon is as active today as it was more than one hundred years ago in the time of Joe Root.

In early June 2009, a group of people packing up late in the evening after a pleasant day at Beach 11 on Presque Isle (the beach closest to Graveyard Pond) saw something quite similar to what Ted and his girlfriend had witnessed more than fifty years ago. The fog had rolled in, and as the people put their picnic supplies and furnishing in the trunk of their car, a figure solidified in the fog. It was transparent and slightly luminescent. A few claimed that it looked like a man dressed in a bathrobe. Those present who knew their history saw it as a sailor in a full dress uniform. It was the uniform of a sailor of the era of the War of 1812. The phantom walked on unseen legs and soon melded back into the fog from whence it came. Frightened, one of the witnesses immediately went to the ranger station and filed a report. In talking with one of the park rangers this June, he was sure that the man had indeed seen something that had frightened the whole group half to death. There was little doubt with the park police that the man was truthful and had been traumatized by the incident. In fact, it became one of the conversational hot topics of the park employees the whole summer long.

Bob Stoner, investigator for *The 24:00 Projekt Paranormal Research*, recorded a strange EVP (electronic voice phenomena) while investigating Graveyard Pond in recent years. The digital voice recorder seems to have caught a disembodied voice whispering, "Help us!"

The crew of the *Niagara* suffered horribly in the winter of 1813, and the name Misery Bay does little justice to the horror that some of the sailors experienced as they were dropped beneath the waves by their fellow servicemen. Weak and helpless, they were weighted down and died an unnatural and ignoble death.

Do their restless spirits rise from the murky waters of Graveyard Pond to try to find their way back to the *Niagara*? Don Guerrein, executive director of the Presque Isle Partnership and author of *A Concise History of Presque Isle: 1753–2003*, claims that there is little support to the legend. In fact, when scouring original sources, there is no mention of the burials. Guerrein

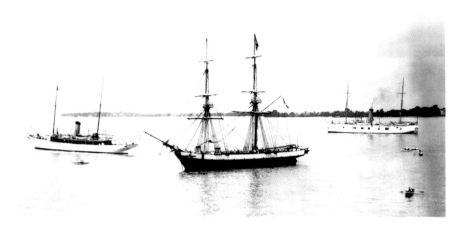

The *Niagara* at Put-In-Bay Harbor, Lake Erie, 1913. *Courtesy of the Library of Congress.*

guessed that the name "Graveyard Pond" came from the scuttling of the ships in Misery Bay. However, the legend of the *Niagara*'s dead has been passed down from generation to generation by Erie residents. Until recently, even the Erie Maritime Museum's website reported the tale as fact, and there were demonstrations of a burial at sea on the flagship *Niagara* tour, with references to the interments at Graveyard Pond.

The restored vessel is now docked right across the bay from Graveyard Pond, near Dobbins Landing, in clear view of the watery graves. Millions were spent restoring the brig. Thousands were spent on a memorial in 1926 that only briefly mentions the suffering and shameful burial of the fallen sailors who had defended an infant United States. There is no memorial honoring the dead themselves, no mention of the names of those who lie in the muck and mud beneath the pond. Is the reported haunting due to the dishonored dead, still incensed at the way they lost their lives and how their mortal remains were treated?

It would not be surprising. Anyone would be upset after sacrificing their all. They deserve better just for the humanity of the situation, let alone because of their status as real war heroes during our nation's infancy. God rest their souls.

PART II
Haunted Places

THE VAMPIRE'S CRYPT OF ERIE CEMETERY

In every community, there are areas of local legend that attract teenagers who use the spookiness of the locality as a sort of rite of passage for the new members of their inner circle. Here in Erie, there are many such places for teenagers to test their will, but one of the strangest is located in Erie Cemetery.

Erie Cemetery sits in the center of town and was founded in 1851. The cemetery is a classic upright stone burial ground, with many large crypts that house the remains of the rich industrialist elite from the city's past. When you enter the grounds, you are amazed at the age and detail of many of the gravestones and crypts. However one crypt stands out above them all.

There is no name inscribed on the top beam like all of the other crypts, and it is darkened as if it had been exposed to fire. The only distinguishing marking on the entire crypt is a V-shaped flourishing. The legends are sketchy and vary depending on who you talk to. But the basics of the crypt legends go like this.

The "V" is for vampire. Inside the crypt lies an undead body of a real, honest-to-goodness bloodsucking creature of the night. He was a wealthy man who fell ill after a trip to Romania, and soon after returning to Erie he

The vampire's crypt. *Photo by Robin S. Swope, additional illustration by Karleigh Hambrick.*

died of consumption. He was buried in the crypt on the southern hillside of the cemetery, and within a week strange things began to happen. Dead bodies were found in the suburbs that surrounded the graveyard. Their blood had been drained, and there were the classic teeth marks on the neck. It was the maintenance man who lived on the grounds who found out the evil creature's secret and then attacked and burned the crypt during the daylight to rid the city of this evil abomination. The family name was scraped from the tomb, and the "V" was etched into the stonework as a warning to all who came near. Its doors were chained and locked shut, never to be opened again.

Back in the days before the police patrolled the area, and when there were dangerous, spiked gates surrounding the graveyard, it was an idiotic challenge to break into the cemetery with an attempt to break into the crypt. While such a thing should not be attempted in our own time—unless one wants to feel the isolation of cold bars and concrete walls as their only friend after being arrested—there is a legend that in times past one foolhardy young lad decided to defile the grave. The rumor is that one time, in the late 1930s, a young teenage boy actually accomplished the incomprehensibly foolish feat of breaking into this vault of rotting flesh. Armed with determination, along with a crowbar and a chisel, the young lad entered the cemetery shortly after sunset to finally see what kind of creature was actually entombed within the giant slabs of granite.

It took him most of the night, but he eventually cut through the locked gate, the chains and the thick reinforced door that prevented both exit and entrance to the old burial chamber. As he pulled open the door, a foul fume rose up from the dark crypt—a moldy, rotten stench that made the young man take a step back and rethink his decision. But he waked into the vault, determined. There on a slab was a rotten wooden coffin with a desiccated corpse. To prove to his friends that he had entered the crypt, he took a ring from one of the fingers and quickly made his way home before the rising sun would reveal his grave robbery.

Excited at his conquest and nervous that he might be caught, he ran to his best friend's house to show off the prize ring. The friend was amazed and shocked, and even though he was admonished to tell no one, the friend could not help but tell all of his friends the next day at school. All of the boys wanted a look at the ring, and many of them went to

the young teen's house. His mother told them that he was sleeping but went to his room to tell him that he had a large group of friends waiting outside to meet him. When his mother entered his room, she found him dead, lying motionless and colorless, eyes wide open and mouth frozen in a horrible scream. And his ring finger appeared to have been literally ripped from his hand. The police were called, and after a thorough investigation (and despite the missing finger), the coroner ruled that he had died from a heart attack. The crypt was locked back up and the gates once again reinforced.

Another tale of paranormal phenomena concerning the area is the supposed appearance of a ghost dog or pack of dogs that appear demonic in nature. It is reported that many people have had encounters with large black dogs that attacked them on the hillside near the vampire's crypt. They appear out of nowhere and then vanish into thin air just as they are about to jump on you. A modern legend tells that an elderly woman once came to place flowers on her husband's grave that is situated by the crypt; she was attacked by a pack of large black dogs that appeared out of nowhere. She ran away in terror, only to look back behind her to see that the dogs had disappeared.

Such is the myth, but the truth is that the crypt is owned by the Brown family. Seven bodies are buried there, and the last recorded burial there was in the 1880s. In-depth research by Rebecca (aka Jibril Ammon) has revealed a very confusing and bizarre history of the crypt while she researched the archaic records of the Erie cemetery and eldritch genealogical records uncovered in reliable sources.

The first burial in the crypt was George W. Goodrich, who passed on in November 14, 1884. Next was Mary A Goodrich, who died March 14, 1888. Six other bodies were also laid to rest there, three of whom were reinterred on September 14, 1888, from other graves: Julia A. Goodrich, who died March 24, 1856; the son of A.J. Goodrich, who died April 27, 1853; and George C. Goodrich, who has no recorded death date. Through genealogical records, Rebecca traced the Goodrich family and found that George was the father and Mary the mother. Their children were Julia, George and Gertrude. Julia and George died young. Gertrude lived on and married Thomas Brown, who was once listed as owner of the Brown Vault. What of the son of A.J. Goodrich? George did have a brother, Chauncey; perhaps it is his young infant son

who was not named. Then again, it is sometimes said that vampires do not like to reveal their real names; since they are evil spirits, whoever knows their name has power over them. While the stylized "V" appears to be a lily flourish, the shape is unmistakable. And why is there no name on the crypt? The lintel does seem to be marred, as if the name had been gouged out of the rock.

Is the vampire's crypt really a paranormal hot spot in Erie? Although the folk tales surrounding its origin are veiled in the vampire mythos, the supernatural stories that surround the crypt in the twentieth century seem to point to curses and demonic entities. Sometimes places of legend that abound in paranormal experiences do not have stories based on historic facts. It seems that the legends are enough to generate the unexplained. Many paranormal experts say that emotional energy is harnessed by unseen forces and manifested in the real world at places such as this. Sometimes seeing comes from believing. Einstein once said of scientific theories, "It is the theory which determines what we can observe." Perhaps the same is true with unexplained phenomena.

What lurks in the vampire's crypt in Erie Cemetery? According to the manager, no maintenance men have entered the vault for decades. Is it because of fear? He did not say, but even the staff at the cemetery calls the vault by that name.

THE HAUNTED CHURCH ON PEACH STREET

Toward the end of 1850, a few families left what was then called St. John's German Evangelical Lutheran and Reformed Church to form a new congregation. This new congregation held their first meeting in December 1850 and called themselves the St. Paul's United Evangelical Church—"United" signifying the unity of faiths that were brought together from both Lutheran and Reformed traditions, with "Evangelical" emphasizing as its mission. Many of these families forming the church were famous early pioneers of the frontier port of Erietown; Fredrick Curtze, Gustav Jarecki, Henry Neubauer, William F.

Nick and J.T. Seven were but of the few prominent early settlers who made St. Paul's their spiritual home. Services were held in the first Presbyterian church before land was bought in 1851 from the Charles M. Reed estate for $1,000. On this property a little brick church was erected that now forms part of the present building. The church was then popularly known as the "Brick Church," a simple standout place of humble worship in a town full of massive stonework edifices of popular denominations.

The first few years of the church were tough ones. First there was a heresy trial brought against the first pastor, Reverend H., Hartmann, by a congregant

St. Paul's German Evangelical Church, circa 1882. *Courtesy of St. Paul's United Church of Christ.*

named J. Hirsch. The pastor was exonerated, and the accuser withdrew from the membership of the church. Because of the turmoil of this incident, the church briefly considered dissolving in the last months of 1852. Soon afterward, mounting debt crippled the church, and administrators had to auction off the pews to satisfy creditors. But soon the church was thriving and growing. Under the leadership of Reverend J. Wilhem Semler, the church added a Sunday school building and a pipe organ and joined the Evangelical Synod of North America. The membership grew and the pews were filled. In 1879, a new front with two bell towers was added on the church, and a parsonage was built beside the church in 1882.

However, more trouble was around the corner. In June 14, 1879, forty-three men and their families left the church because they wanted the church

to have English- *and* German-language services. They organized the St. Luke's Evangelical Church. Another split was instigated by the church's pastor of thirty years—Reverend Valentine Kern split off in 1906 to form the Christ Evangelical Church.

St. Paul's is now a church under the denominational auspices of the united Church of Christ, and over the years thousands have made St. Paul's their spiritual home. It seems that some have never left. For many years, members of the congregation have noticed odd things happening in the church: footsteps when nobody else was in the building, doors opening and closing, strange whispering voices and so on. Choir member and lifelong parishioner Denise Gibson remembers hanging around with her father at the church many a late night. Denise's father was the church sexton for many years, and so they were often alone at the church in the evening, cleaning. Not only would she hear disembodied footsteps walking down the empty corridors of the church's education wing, she would also often hear the whispering voices of people who were not there. You would think that such a thing would frighten a young girl, but Denise quickly learned not to fear the phenomena that often occurred frequently those late nights. Denise sensed that they were not there to harm her in any way; she sensed that they were actually old church members who were either carrying on their duties in the church, just as they did while they were living, or were friendly guardians who had passed on that were visiting the place that had strengthened their faith throughout their lives. As a teenager, Denise remembers all-night lock-ins where she and the youth would sit in the back of the church sanctuary in the dark, watching the pulpit and choir loft. They would watch living shadows moving back and forth as if a phantom worship service from days gone by was manifesting itself before their eyes. Sometimes, when the conditions were right, they could even hear the faint refrains from the spectral choir.

Denise is far from the only church member who is vocal about what she has encountered at St. Paul's. Cheryl Pierce has been the church secretary since 2001. She has had a long history of encountering the invisible inhabitants at St. Paul's United Church of Christ, and she thinks that she used to know some of the specters while they were living. Cheryl remembers a young girl from the congregation in her early teens who had grown up in the church. She always had a cheerful attitude, a smile on her face and an

St. Paul's confirmation class of 1901. *Courtesy of St. Paul's United Church of Christ.*

infectious giggle that brightened the darkest of days. She loved children and was delighted to help out in the nursery whenever she could. When Cheryl's older son, Ben, was just a baby, this lighthearted teen girl would lavish attention on the young boy. They had a special bond; she would always hold him close and play baby games like peek-a-boo or nonsense talk, and young Ben would coo back in delight.

One day in the summer of 1994, tragedy struck. On the way back from church camp with the pastor, the van they were riding in had a freak accident. The young teen girl was killed instantly as the church van hit a tree. The whole church was in mourning for this young girl who had given so much love to so many people. But if Cheryl and her son Ben are correct, the young teen never really left the church when she passed on that summer day. Every once in a while, Cheryl will hear that unmistakable giggle wafting down the hallway when nobody else is around. Sometimes the giggle is accompanied by footsteps or the door to the nursery opening and closing on its own. Cheryl's son Ben is now in his twenties, and one evening he was sitting at the church computer

when he sensed that someone was behind him. As a hand gently caressed the back of his head, Ben quickly turned around to see who it was but only saw that he was alone in the room. Ben still sensed the presence in the room, though—it was the young teenage girl, still watching over him with tender care after all these years.

The young teen girl is not the only caring spirit still abiding at St. Paul's. Ruth Breene was an elderly woman who wore a distinctive vanilla perfume. She was always dressed in high heels and stylish outfits, with accessories that were highly popular in the 1960s. She also loved to work in the nursery, overseeing all of the little ones while their parents worshiped in the sanctuary. She died in the mid-1990s of old age, a dedicated church worker until the end. It was impossible to find someone to replace her, with her sincere affection and tender patience with the babies and toddlers. Many stepped in to help, but Ruth was sorely missed. It seems that she also had a hard time being separated from St. Paul's nursery in the afterlife. Ruth's spirit is one of the most active on the second floor of the education wing at the church. The distinctive *click-click* of high heels on the polished linoleum floors is often heard in the afternoon and evening hours. She makes the trek from the main stairway to the nursery, and like the teenage girl, she opens the nursery door and goes in to tend to the children, like she did for so many years in her lifetime. Every once in a while, you can also catch a whiff of that distinctive vanilla perfume; it is a brand that has long since gone out of production. But the scent lingers with her spirit and high-heeled footsteps in the hallways and nursery of St. Paul's Church.

Many have also sensed a mischievous spirit lingering at the church. Clarence was a cheerful soul, always telling goofy stories or making practical jokes at choir practice and church dinners. When he passed on years ago, his lighthearted shilly-shallying and merry pranksting was not forgotten. How could it? It never ended. Every once in a while, an unsuspecting person will get a poke on the shoulder and turn around to see that nobody is there. Clarence made you look! Things will go missing when you know for certain you had just put them down, and they will end up in the oddest places. When you are alone in a room, you feel that someone is right behind you, and you get the goofiest feeling. Clarence is at it again, always a clown to cheer your heart from this life or the next. He always knew that a good chuckle cleared the gloomy heart, and he continues that joyful ministry even in death.

There have been various other incidents that many of the congregation have experienced that cannot be pegged to one specific individual. After one Thanksgiving weekend a few years ago, Caitlyn Pierce was setting up the antique manger scene on the church altar when she heard a woman's voice speak to her out of nowhere. "Be careful with those," the elderly woman's voice said. Caitlyn looked around to make sure that she was the only person in the sanctuary; nobody was to be seen.

In 2008, Church Council vice-president Craig Fischer wanted to see if all of these experiences could be verified by a scientific investigation by local paranormal researchers. A longtime aficionado of unexplained phenomena, Craig wanted proof that what members of the congregation were experiencing were not just figments of their imagination. Local historian and paranormal author Stephanie Wincik suggested a few local investigative teams, and Erie County Paranormal came to investigate the church on November 1, 2008. It was fitting that the investigation took place on this day, which was All Saint's Day, a church holy day to remember Christian servants who have passed on to the afterlife.

The group, headed by Frank and Debbie Grande and Jerry Thompson, set up three cameras in various areas of the church and used the sanctuary as home base. One camera was in the sanctuary, one in the church office and one in the second-floor chapel. Although not seen until the tapes were reviewed, at 10:05 p.m. a flurry of activity appeared on the camera. First the camera in the chapel showed a dark shadow being walking quickly past the door toward the nursery and back toward the office. It was just a torso, with no lower portion of a body. Seconds after this, a lighter shadow being shaped like a woman in a long dress came through a closed door in the church office; it looked around and left the same way it entered. The video was amazing, crystal clear and defined. Nobody was on the second floor at the time; everyone was accounted for. The group also caught a number of disembodied voices with their hand-held digital recorders, but nothing was as astonishing as the shadow people caught on camera. This video was later highlighted on the Discovery cable network's paranormal show *Ghost Lab*.

Following this initial investigation, Erie County Paranormal has returned to St. Paul's numerous times. With each new examination, the group has caught more and more evidence that there is paranormal

activity at the church. During its second investigation, the group caught an EVP in the choir loft, the voice of a young girl saying, "It's ok to die." The members have also caught the audio of the high-heeled footsteps of Ruth going from the staircase to the nursery and the door opening and closing. In the nursery itself, they have also found curious supernatural activity. An EMF (electromagnetic field) detector flickered when the group questioned if there were any deceased church members in the room, which according to the researchers shows the spirit answering in the affirmative. A ball was rolled back to one investigator when she asked if there was anyone in the room who wanted to play. On another visit, the rocking chair that nursery attendants would sit in was found rocking on its own accord.

Another hot spot in the church is the basement fellowship hall. Two investigators saw tiny flickering spots of light dancing across the ceiling near the florescent lights. At another time, an interesting EVP was heard in the fellowship hall, it sounded like a group of children playing. Young voices are clearly heard laughing and giggling, while footsteps and various activities were heard in the background. Of course, no young children were present at the time. Interestingly enough, the basement fellowship hall used to house another building that, at this level, contained a large children's Sunday school class.

Jerry Thompson of the Pennsylvania Society for Paranormal Research had some interesting experiences while investigating the church with Erie County Paranormal. The third floor of the church is dedicated to the Upper Room, an ecumenical shelter for Erie's homeless population. While sitting in one of the third floor's larger rooms that once housed a chapel, Jerry heard footsteps approach him. The footfalls went right past him, as if some invisible entity went around him. While on the second-floor stairwell, Jerry heard a loud male voice on the third floor. Since the third-floor doors are locked from both sides to prevent the homeless from wandering through the church uninvited, Jerry thought that someone was on the third-floor stairwell talking to someone. But there was no living soul there. Jerry also caught an interesting EVP in one of the old Sunday school classrooms on the third floor. As he was walking through with a group of people, a voice in the background clearly said, "The staff won't leave!" Jerry's thought was that it might have been a homeless person's spirit who was vexed by seeing so many people still in

the building that he had considered home in the last months of his life. Indeed, a few temporary residents of the Upper Room met an untimely and occasionally violent death after their time in the shelter. Such is life living on the streets, and perhaps a poor wayward soul found St. Paul's as its last mortal home on earth.

Other groups have investigated the church, with a mix of results. James McCann, of A Paranormal Group Erie County Pa (APG/ ECP), caught many interesting EVPs at the church during his group's investigation. One voice was heard to say, "I love you Father," along with many other phrases with religious connotations. While at the church, noises of large items moving across the third floor were heard by the entire team. At the time, even the video cameras could attest to there being no one on the third floor. Other groups have come to the church

The old Christian education section, which is now the fellowship hall location. *Courtesy of St. Paul's United Church of Christ.*

and hardly encountered any evidence at all. One group only had one EVP, and that was only after a church member who was watching the building came in and participated in asking if there were any deceased church parishioners in the room. The EVP they caught was that of a young girl giggling.

Every October, St. Paul's United Church of Christ is host to a "Haunted Ghost Tour," open to the general public. Erie County Paranormal presents its evidence and lets the guests use the equipment to do their own investigation under their guidance. The funds raised have helped restore the church's bell tower, allowing the church bell to ring for the first time in many years. Guests have encountered paranormal activity during these events. One person saw a phantom elderly man sitting in the church narthex in between tours when nobody was there; at another time, an entire family saw shadow figures walking across the choir loft.

The paranormal activity at St. Paul's continues to this day. Recently, a giant ball of light was seen hovering in the sanctuary near the front pews. It was more than three feet in diameter and slowly faded as the witness came into the sanctuary from the sacristy. There has also been whispering voices heard in the stairwells when no one else is in the building. Of course, there still is the frequent supernatural activity of Ruth, Clarence and the young teen girl. When Christians and other religious people hear about the activity at the church, one of the common questions is, "How can a church be haunted?" However, haunted churches are more frequent than one might think. There is a vast history of haunted places of worship from all over the world. It makes sense: if you have spent the majority of your life investing time and money to help others and worship God, wouldn't you want to stop by and see how the place is doing if you had the chance? St. Paul's is the place where thousands have heard about the resurrected Christ and have developed a deep spiritual life. The spirit of God has blessed many here, and Christ's love is evident in his people at St. Paul's the minute you step through the door. Perhaps there are many who have passed on from this life who are lingering here until the great resurrection, when Christ returns in his glory.

RECENTLY LOST HISTORIC HAUNTED PLACES

It may seem very pithy, but it is true: time marches on, and nothing lasts forever. However, it is very emotional and dreadfully sad when an often loved historical site is lost forever because of change or human ignorance. Within the last two years, Erie County has lost two historically "haunted" places. These places were areas where, late at night, the mind would run wild and, in the remote country, odd sounds would take on a life of their own, with your imagination as guide. Both sites were on the rural edges of the West County, surrounded by forest with only a few residences nearby. Both were magnets for teens seeking thrills on warm summer nights. They were Gudgeonville Bridge and Axe Murder Hollow. One was taken by a vandal's fire and the other by suburban sprawl.

Gudgeonville Bridge was built in 1868 and remained for 140 years as a quaint rural reminder of days gone by. One of Erie County's historic treasures, in September 17, 1980, it was inducted into the National Register of Historical Places. In its later years, the antique bridge's covered wooden structure began to show its age, and it began to have a very unique and eerie mystique. Many legends of ghosts and spectral donkeys brought seekers of the paranormal to the bridge from all over the tri-state area. Stephanie Wincik in her book *Ghosts of Erie County* detailed most of these legends and experiences of local residents. Sadly, on November 8, 2008, the bridge was destroyed by two arsonists who wanted ignoble notoriety. In an odd coincidence, fire had damaged the bridge soon after it was first built, and in 1870s it had to be reconstructed. A flat and open bridge has been constructed at the site, but the historical structure long loved and admired by county residents has been lost forever.

However, even though the historic bridge has been lost to time, the ghosts of Gudgeonville still haunt the crossing at Elk Creek. James McCann, founder of the paranormal team APG/ECP, is a local expert of the paranormal history of Gudgeonville. He has spent many long hours investigating the bridge site and has found many astounding things there, both historical and paranormal. He has found that there is one verifiable historical fact behind the multitude of legends of the site. On April 19, 1964, Darlene Marla Nicholas, an adorable ten-year-old girl, was walking along a cliff side

Gudgeonville Bridge in August 2007. *Courtesy of James McCann.*

by the bridge with her mother. Darlene loved her little sister and wanted to pick some of the colorful moss from the tree trunks that lined the side of the cliffs so she could bring it home to her little sister as a present. Erie County is almost always wet in April, and as little Darlene stooped down to pick some moss, she lost her footing and tumbled down 225 feet to her death. Her broken body was found facedown in a small pool of a half-inch of water. Ever since that time, people have heard screams of a little girl and apparitions on the cliff.

James has also had many personal experiences with the unexplained at the Gudgeonville site. While the bridge was still intact, he caught strange lights rising from the bridge on video that can be seen on his YouTube page. He also has caught some stunning ectoplasm photographs both before the bridge burnt and after. Ectoplasm is supposed to be energy that is manifested as a cloud or mist by spirits as they interact with the physical world. In many of James's photos, you can make out a horse or

donkey, people or even young children. One of his recent photos has a spectral figure that looks like an alien or fetus with a large protruding eye. From his personal experiences and talking with many other paranormal investigators, James has listed common unexplained occurrences that become manifest at the bridge site to this day. People still see shadow people walking across the bridge or appearing on either side, small pebbles are thrown at visitors in the middle of the night and disembodied voices are often heard whispering softly in the evening breeze.

The Gudgeonville Bridge of historical significance may be gone, but unexplained events can still be witnessed by the stalwart investigator. The eerie mystique of the site may be a thing of the past, but the legends continue.

Axe Murder Hollow is located on Thomas Road in Millcreek Township. Here, too, a plethora of legends surround the third bridge on this road, which is located at the first valley going south from Sterrettania Road. Stephanie Wincik again most eloquently details these in her book on Erie County ghosts. But the legends that have surrounded this little dip in what was an old country road are not unique to this site. The two more popular stories that surround the site are urban legends that are common throughout America. The vengeful husband killing his wife and her ghost appearing as witness to the horrible crime has been a popular story for centuries in a multitude of localities. The second story of a modern young couple parking at the site and the boyfriend's murder, made popular by writer S.E. Slosser, is a spin on the urban legend of "The Boyfriend's Death," which is well documented at the Snopes website on popular urban myths. Both of these legends have no historical background in a true event whatsoever. However, Axe Murder Hollow has been the site of a grisly murder in the past, and that horrific tale is well documented indeed.

On Saturday, January 19, 1963, beautiful Edinboro University coed Mary Lynn Crotty went on a blind date with twenty-one-year-old Daniel Roy Biebighauser. Mary, a twenty-year-old sophomore who was a Lawrence Park native, was very popular young girl; she initially went on the outing as a double date with her best friend, Paulette Cywinski, and her boyfriend, hoping to make the rounds at local bars. The January 22, 1963 *Erie Times News* reported that Mary had told her parents that she was going to spend the night at a friend and classmate's home as a

cover story for a night of drinking. However, unbeknownst to Ms. Crotty and her classmates, Daniel Biebighauser was a married man with some severe mental issues.

After a full night of hitting the popular drinking establishments, the inebriated couples stopped at Mr. Biebighauser's newly purchased house near East Twenty-sixth and Parade Streets. The house was nearly empty, as Mr. Biebighauser's family was in the process of selling their old home before moving in. As the older married man began to make his moves on the unsuspecting coed, she felt very ill at ease and requested that she be taken home. She got in the car with Biebighauser, and instead of taking her home, he drove to a remote part of Thirty-eighth Street near Cooper Road in Harbor Creek Township, stopped the car and made more advances on the young girl.

According to the article, when she resisted, he ripped her clothes off and assaulted the girl. In the ensuing struggle, he strangled the girl into unconsciousness; he then put her in the back seat and raped her. As he was performing his treacherous deed, the young girl began to regain consciousness. Biebighauser then choked her again until she was dead. After he was done, he threw her body into his trunk and went home to his wife, leaving Mary's dead body in his trunk over night. The next day, Biebighauser tried to cover his tracks; he drove to Mary's parents' home in Lawrence Park, tying to appear as to visit the girl after a date. When her parents told him that she had not returned home, he feigned concern over the missing girl. As the parents called Ms. Cywinski to find out what had transpired, Biebighauser drove to Axe Murder Hollow, where he tried to cover up his foul deed. He pulled the body from the trunk and dragged it into the woods; with cold determination, he slashed Mary Lynn Crotty's throat and stabbed her in the chest fifteen times. He then dumped her body in a snow bank and threw her clothes along the highway in the hopes that someone would discover the corpse and leave the police to suspect that someone else had kidnapped and murdered the girl. However, fate would soon catch up with him; at about 1:00 p.m. on Monday, January 21, 1963, Detective Penman of the Pennsylvania State Police went to Biebighauser's apartment to question him further about the disappearance of Mary Lynn Crotty. Biebighauser agreed to move the interview to the police station, wishing to have it out of the presence of his wife. After forty-five minutes of interrogation, Biebighauser

confessed. On May 22, 1963, he was convicted of first-degree murder and sentenced to life in prison.

So while the legends are merely urban myth, a horrible deed was indeed committed at Axe Murder Hollow years ago. Back then, the secluded rural setting was the perfect place to conduct business that you wished nobody to witness. Oddly, according to Millcreek police, years ago it was also the scene of many suicides. The lonely stretch of road in the middle of nowhere attracted the lonely, the forlorn and the mentally disturbed.

Today, Axe Murder Hollow is no longer a secluded rural road off the beaten path. Since the renovated Asbury Elementary School made the area its home, a growing housing subdivision has quickly overtaken the area in the vicinity of Axe Murder Hollow. Hundreds if not thousands of residents live within throwing distance of the once dreaded site. The old steps to the mysterious abandoned farmhouse are long gone. Whereas in days gone by, cars would be parked along the roadside as teenage thrill seekers would venture forth for a chance encounter with a ghostly ghoul, signs all along the road now note that cars parked along the roadside will be ticketed and towed by the local and state police. Axe Murder Hollow, with all its legend and mystery, is lost to the ages.

Time marches on and nothing lasts forever, except perchance for the unseen forces that abide, untouched by mortal hands. As we progress into the twenty-first century, Axe Murder Hollow and the antique covered Gudgeonville Bridge will reside only in our memories and the annals of history.

PART III
UFOs

CLOSE ENCOUNTER AT PRESQUE ISLE

Project Blue Book was a specialized study initiated in 1952 by the United States Air Force to investigate the subject of UFOs. By the time the study was concluded in 1970, the air force task force had investigated 12,618 reports of unidentified flying objects. Most of these cases were explained as conventional aircraft or natural phenomena such as clouds, stellar objects or solar activity. However, there were a handful of cases that defied explanation; people had real encounters with unknown craft and their occupants, which led the air force investigators to classify them as unexplained. One of these unexplained cases happened right here in

Erie, Pennsylvania, on Presque Isle's Beach 6. It was Project Blue Book's case number 10798, and despite some claiming explanations, it remains unexplained to this day.

It was a warm and inviting summer evening on Presque Isle's Beach 6 on July 31, 1966. A group of young people from nearby Jamestown, New York, had decided to spend their Sunday afternoon enjoying the beach and having a cookout on the beach for dinner. Eighteen-year-old Douglas J. Tibbets and sixteen-year-old Betty Jean Klem had come to Presque Isle with twenty-six-year-old Gerald LaBelle and twenty-year-old Mrs. Anita Haifley, who had brought along her two young children, two-year-old Sandra and six-month-old baby Sara. The sun was beginning to set, and after loading the car, Mrs. Haifley started it; as the engine revved, the foursome knew that there was trouble. The car had become stuck in the sand at the east end of the parking lot, where the volleyball courts now stand, and they were not going anywhere. The more they tried, the further stuck in the sand the car became. The men got out and tried to dislodge it, but try as they might, it would not budge. So Mr. LaBelle hitched a ride with another group leaving the park in order to find a tow truck to pull them out.

Within the same hour, park patrolmen Ralph E. Clark and Robert Loeb Jr. pulled into the Beach 6 parking lot to make sure that the visitors were making their way out of the park when they spotted the stuck vehicle. They checked out the car and promised the three remaining adults that if Mr. LaBelle could not locate a tow truck by the time they would circle back to the beach on their rounds, they would offer what assistance they could. As they sat in the car waiting for LaBelle's return, something odd happened at about 9:30 p.m. The *Erie Times News* of August 1, 1966, records Mr. Klem's account of what happened next: "We were sitting in the car waiting for help. We saw a star move. It got brighter. It would move fast, then dim. It came straight down. The car vibrated. I know we saw it; we had taken a walk in that area earlier. There was nothing between those trees then. All of a sudden it was just there."

According to the witnesses, the object was a large, luminous, mushroom-shaped craft with a narrow base rising to an oval structure. There were also bright lights on the back of the object. The UFO approached from the north and briefly hovered over the area before landing. Ms. Klem said that a beam of light came from the craft and moved along the sand in a straight line as the craft disappeared behind the tree line: "It lit up the whole woods in the

path. It wasn't like a search light. There was light along the ground, along the whole path."

She said that the light did not waiver but rather continued to extend into the woods. About this time, the patrol car with officers Clark and Loeb returned, as promised, to offer assistance. Immediately, the light from the object extinguished. The officers approached the car and were told of the craft that had landed in the woods, and Mr. Tibbets offered to show them the general area where he thought it touched down. With Douglas Tibbets leading the way, the officers followed along—leaving the two young women and the children alone in the car. Only a few moments had passed when Ms. Klem and Mrs. Haifley, who were sitting in the front seat of the car, saw something large emerge from the woods where the officers and their young friend had just entered. It was dark, but the girls could make out a large, shadowy figure walking through the trees toward their location. At first they thought that it could have been an animal, but the immense size of the thing soon quelled that notion. It looked to them to be a black, featureless humanoid creature over six feet tall and covered with hair like a gorilla. It made its way out of the edge of the woods and came straight toward their car.

The girls were frozen in fear. In a June 12, 2008 interview with Mr. LaBelle, he related that the girls told him that the creature at first circled the car from a distance, and then it slowly tightened the circle until it was right next to the automobile, at which time the thing began to claw at the car. Immediately Ms. Klem and Mrs. Haifley began to scream and frantically honk the horn. The creature then sluggishly moved back into the brush, and the UFO rose and took off with incredible speed to the north just minutes before Mr. Tibbets and officers Clark and Loeb came running to their aid. To highlight the urgency at which they arrived, Mr. LaBelle was told that one of the officers actually lost his service pistol in the sand and decided to forgo the seconds it would take to recover it in order to reach the distressed women as soon as possible.

Both girls were in a state of panic, and it took them a while to calm down. Mrs. Haifley was in such shock that she refused to talk about the incident. Ms. Klem initially refused to talk about what had happened also, but once she was removed from the location and taken to the park ranger office, she was able to piece together the shocking incident for the officers. Indeed, all four adults and the two children were taken to the

Location of the landing site in relation to the car. *Courtesy of the* Erie Times News.

ranger office by patrol car, leaving the stranded car stuck there in the sand. According to Mr. LaBelle, more heavily armed patrolmen came in to assist with the questioning of the witnesses, and they refused to let the young people go back to their car to retrieve their belongings until morning. They wanted the scene to remain undisturbed, and it was these officers who upon investigation noticed that there were indeed strange, deep scratches on the abandoned car.

By 7:00 a.m. the following morning, the state police and United States Air Force were involved. Officers Paul Wilson and Robert Canfield investigated the area and found unusual impressions in the sand. About 350 to 400 yards away from the car, two diamond-shaped imprints about eighteen inches wide and six to eight inches deep were found ten to twelve feet apart. In another place, three impressions were found in a triangular pattern about eleven feet apart from one another.

While surveying the area, Officer Wilson found tracks that led in a straight line to the car. They were conical in shape, about eight inches wide, five to seven inches deep and five to eight feet apart. Along the path of the footprints, the air force investigators from Project Blue Book also found some

unusual hairs of an unknown animal. These hairs were found at an unusual height and spanned a large width across a tree limb. Their placement upheld the description by Ms. Klem that the creature was over six feet tall and of enormous size.

Officer Wilson reported that he did not believe that they were footprints but seemed to have been made by some kind of heavy object or objects. Sometime during the morning, air force investigators took a statement from Ms. Klem. Soon after the incident, she was also interviewed by a psychiatrist, who affirmed that the testimony she gave about the incident seemed to be true and not due to illness or delusion. Once the story hit the newspaper and local television, Presque Isle soon became crowded with sightseers who hoped to catch a glimpse of a UFO. It became a local craze to spend the night on the lakeshore and go flying saucer spotting. The air force investigators had collected their evidence and, after a thorough analysis, deemed the case as officially unexplained.

However, in recent years, this official verdict has been challenged. Investigative reporter Brian Sheridan from Action News 24 did a

The creature's footprint. *Courtesy of the* Erie Times News.

segment on the Presque Isle incident in his "Erie Flashbacks" series. His initial segment interviewed park policeman Ralph E. Clark, who gave an account of the incident that seemed to contradict the initial *Times News* report in some crucial areas. When this initial positive segment aired, the ABC affiliate received numerous letters or calls from various individuals who claimed that the incident was a hoax, and one of them stood out from the rest. Mr. Sheridan received a phone call from a local truck driver, Mr. Kim Faulkner, who said that on that July night he had launched a papier-mâché hot air balloon (that he had bought from an ad in *Boy's Life* magazine) from his house at 1817 West Twenty-second Street in Erie. Mr. Sheridan recalls that Faulkner seemed genuine:

> *His brother confirmed the story Faulkner told. We also found the* Boy's Life *ad he mentioned. He was also the only one who contacted us after the first story ran who did not claim they did it as a hoax or prank. It made the most sense of anyone we talked with at the time. Other people just wanted to brag. Faulkner didn't even want to go on camera. He just called to fill me in on the story after his brother told him about the first piece we aired.*

Faulkner had launched the balloon at his house near Twenty-second and Greengarden and saw it lift off into the air. When news hit the next day of a UFO being sighted at Presque Isle, he assumed that it was his balloon that had caused the incident and remained quiet at the time for fear of getting in trouble with the authorities. It was not until he saw TV 24's report that he decided to come forward with his experience. Mr. Sheridan aired a follow-up segment to the original in which he declared that the UFO case was no longer unexplained and that it was an unintentional hoax by a little boy and his papier-mâché toy balloon.

However, upon comparative investigation of the details of Faulkner's story with the weather reports of the day of the incident, it is impossible that the toy balloon launched from Twenty-second and Greengarden could have made it to Beach 6 on July 31, 1966. According to weather records, the winds off Lake Erie on that evening were coming from the southwest, varying from nine to twenty-two knots. That would take the balloon in a northeastern direction, missing the peninsula entirely. For the balloon to have been responsible for the incident, it would have

had to travel in the opposite direction, which would be northwest, for a considerable period of time. Even given Erie's unpredictable currents, with a steady southwest wind coming off the lake, the little balloon would have ended up many miles northeast of Beach 6 at the time of the encounter. It is also a leap to compare the initial witnesses' description of the large UFO with searchlights to a small seven-foot-tall red-and-white striped paper balloon held aloft by tin plates and an improvised Bunsen burner. While Mr. Sheridan's report is very well done and, at first glance, a practical explanation for the encounter at some level, it does not hold up with the facts at the time.

When told such an incredible story, many people's first reaction is that either the people were delusional or that they were perpetrating a hoax. Mr. LaBelle even reports that he was accused of fabricating the incident by using a flashlight and playing tricks on the passengers in the car for a practical joke. But after all the passing years, he and the remaining survivors hold true to their story. It is a little-known fact that these six individuals were not the only ones to have seen that UFO on July 31, 1966.

In the August 1, 1966 *Erie Times News*, a side story is included with the initial report of the UFO at Presque Isle titled "Eight Others See 'UFO' in Erie Area." These eight individuals saw a UFO the same evening between the hours of 8:00 p.m. to midnight. Steve Lupe was on Beach 2 with a group of friends that evening, and he along with three others spotted an object hovering near the peninsula at about 8:30 p.m. French exchange students Helena Roche and Alain Orcel, living at 412 Frontier Drive about a mile away from the beaches of Presque Isle, saw a lighted silvery object flying low that evening. Stephanie Mango of 4704 Homeland Avenue also saw it, saying that it flew silently at treetop level. It was round and its color was undistinguishable. The object moved toward the beach and then changed course and moved toward Erie's Bay area, where it disappeared from sight. Sue Karie, Linda Henderson and Janice Dickey were sleeping out in the yard of the Karie household at 1012 Shenley Drive when, at about 11:00 p.m., they spotted the silvery object flying from south to north. She reported that "I heard a whistling sound and looked up and saw an object moving north as high as The Boston Store (about 138 ft). It was very low, and we all ran and got into the station wagon and locked the doors when we saw it." She said at first that it looked like a star but that it kept fading in

and out. It was round and saucer shaped, and they saw it for a minute, after which it disappeared.

Since these initial reports, others have also stepped forward to report that they had seen an Unidentified Flying Object over the skies of Erie on that Sunday night in 1966. Fred Lane, a community activist who now resides on Dunn Boulevard, was watching the sunset over the peninsula from nearby Lighthouse Park with a friend on July 31, 1966. As the sun went down, they both observed a hovering red object over the bay that pulsated with light. After a few seconds, the pulsing increased, and the object hurled itself with unbelievable speed to the north across Lake Erie.

Steve Duda, who owns a trucking business in Albion, had a strange encounter that night as well. Steve was hauling Deans from Buffalo to West Springfield on the evening of July 31, 1966. He had done the route countless times in the months preceding this trip; it would take him two to two and a half hours to complete the run. He had left Buffalo at

The creature's footprint as pointed out by Tibbets. *Courtesy of the* Erie Times News.

about 9:15 p.m., so he expected to be pulling into West Springfield at about 11:30 p.m. or a tad bit later. Just inside the Pennsylvania line, Steve felt odd, like he was coming out of a dream. He wondered to himself if he had nodded off behind the wheel but immediately another feeling overwhelmed him: the sense of pure, hair-raising fear. The cab of his truck was strangely illuminated, as if he was driving in the noonday sun instead of the evening hours. He also noticed that he was alone on the highway, a very odd thing that he had never before encountered in all his years of traveling on I-90. Then he noticed the source of the light: behind him was an enormous sphere that lit up the highway. It was as large as both lanes of the interstate highway and luminous, with a black dome on top. It rose up and quickly flew away toward Erie at an unbelievable speed.

Very shaken, Steve continued his haul to West Springfield. He parked his rig, got into his own vehicle and headed home. As soon as he entered his house, he asked his wife if she had seen anything strange being sighted over the county in the evening news. His wife just gave him a blank stare. "Steve the evening news isn't on for another hour." Confused, Steve looked at the clock on the wall; it was 10:20 p.m. He had just traveled the 120-mile trip with an eighteen-wheel rig in close to an hour and had made it home to boot. What had happened to Steve Duda on that long stretch of I-90?

Soon it would become apparent to Steve that something more than a stretch of time had happened to him that hot July night. He soon realized that it had done something to his mind. Steve had somehow become clairvoyant; he not only could read minds, he could also project his thoughts into the minds of others. He remembers walking down a street and seeing a beautiful girl, and in his inner dialogue, he remarked how good-looking she was. The woman stopped and asked him, "What did you just say?" But he had said nothing. His mind had broadcast his thoughts. Steve could also see things that were transpiring in distant places, and he learned to trust his feelings and adjust his schedule. Once he was suppose to make a long run when he felt that he should deliver a shipment of lime to the Agway in Union City. He arrived with the shipment, and the manager told him that he had just been talking about him. Steve told him that he knew that, and he told the manager exactly who he had just talked to and when the call was placed. His altered senses did not always give him

pleasant experiences. Steve remembered visiting his sister one day in 1992. Once there, he knew it would be the last time he would see her alive, even though at the time there was nothing wrong with her. Sure enough, within the year, his sister was dead; at the funeral, he had the chilling realization that he had vividly seen this very moment over a year before.

Something strange and otherworldly interacted with many people on July 31, 1966. These incidents changed people's lives and their perception of the nature of the world in which they lived. Highly trained experts from the government were perplexed by what they found that summer day many years ago. And after all these years, Project Blue Book's case number 10798, the close encounter at Erie's Presque Isle Peninsula Beach 6 on July 31, 1966, is still officially unexplained.

A HIDDEN UNDERWATER UFO BASE IN LAKE ERIE

On Thursday, November 13, 2008, many people along the shores of Lake Erie from Ashtabula to Madison, Ohio, reported hearing something crashing into the lake. Two people called 911 to alert emergency services of what they took to be the crashing of a small plane into Lake Erie just off Route 20 near Madison. Police and firefighters from two local townships searched the area, only to find no wreckage. Madison Township police sergeant Rick Barson was quoted in the *Ashtabula Star Beacon* as saying, "We had enough information from two people in separate places that seemed to have seen the same thing, but we had trouble getting a good description that would fit the type of craft we believed this plane could be." A full search and rescue operation, including two local news helicopters, searched the area for debris. When nothing was found, the assumption was that witnesses had observed a small meteorite crashing instead of an aircraft. Or was it? Lake Erie has a history of strange lights, unexplainable things coming in and out of the lake and assorted oddities that point as evidence that some massive objects have mysteriously slipped beneath its waves.

Lake Erie is one of the smallest and the most shallow of the Great Lakes. It has a surface area of 9,940 square miles, with a length of 241 miles and breadth of 57 miles at its widest points. It has an average depth of 62 feet and a maximum depth of 210 feet, most of this depth having almost no visibility because of the massive floating sediment that permeates most of the lake. Salvage divers have noted that even in the shallow parts of the lake, visibility is limited to about 2 to 3 feet. Although not the greatest in size and depth of the Great Lakes, it gives a perfect place for underwater clandestine activities.

For centuries Lake Erie has been host to a phenomenon that many in past eras have called "wizard lights." In the December 12, 1867 issue of the *Brooklyn Eagle* there is an article titled "A Curious Phenomenon on Lake Erie" in which is recounted the instance of a burning ghost ship seen off Erie. The writer reports that local sailors have been seeing these lights for more than fifty years throughout the area. Recently, places on the western part of the lake, such as Sandusky and Cleveland, have been hotbeds of UFO activity, and similar lights have been filmed, making them YouTube sensations. These UFOs have been investigated by world-famous UFO researchers and have even been the focus of such cable television shows such as *UFO Hunters* and *UFO Files*. Cleveland ufologist Aaron Clark in the March 8, 2007 *Cleveland Plain Dealer* declared that "[s]ome believe there's a UFO base on the bottom of the lake."

However, odd stories emanating from Lake Erie in past centuries do not limit themselves to just the phenomenon of wizard lights alone. Huge waves have hit the north coast of Ohio and Pennsylvania at least twice, in 1882 and 1942. In both of these incidents, the lake was calm just before the waves arrived. The 1882 wave was more than eight feet high, and it came ashore at about 6:20 a.m., and like a tsunami it destroyed everything in its path and carried it inland. Huge logs were carried hundreds of feet, fires were extinguished at the Lake Erie mills, barges were tossed onto dry ground and the mooring lines snapped on many ships. The 1942 wave was even more immense, towering at fifteen feet high; as it hit the shore, seven people lost their lives. Oddly, the lake was calm as the approaching wave swept along silently until it reached shallow water, where it made a loud crashing noise and broke on the shore with a great roar. There was only a single, dark cloud very far out in the lake, and many heard a loud noise break the morning stillness just minutes before

the wave hit shore. There was no reported earthquake, and many claim that the waves were caused by freak thunderstorm winds. But even taking into account the unpredictable weather often experienced on the lake, such huge waves without a massive storm front are hard to imagine. But what if the immense waves were caused by something large crashing into the lake? It would explain the loud noise heard in over the lake, and the waves would then have been just a gargantuan ripple effect.

Whatever the cause of these phenomena, one thing is sure. Something odd is happening over Lake Erie. After the mysterious crash of November 2008, other West County and eastern Ohio residents came forward with their own stories of unidentified craft moving over Lake Erie. The *Ashtabula Star Journal* also reported that the year before, forty-seven-year-old Wayne Cavinder also sighted a fiery light crash down into the lake late one night. He was quoted as saying, "I called the police, and they acted like I was crazy. Now, after other local UFO sightings have been reported, I'm vindicated." Another witness, Jeni Collins, reported seeing unidentified objects flying over the lake all the time, going up and down into the horizon at night.

However, UFO sightings over the lake are not uncommon, and the witnesses are usually very credible. The *Erie Times News* reported that on August 3, 1966, two Erie County police officers, one from the Wesleyville Borough and one from Lawrence Park Township, saw a large, red, glowing object flying back and forth over the lake. They watched it for quite some time until the sun rose and revealed it to be a large, disk-shaped object that then quickly flew out of sight to the north.

At about 8:45 p.m. on March 4, 1988, Sheila and Henry Baker were driving home with their three children. As they drove near the waterfront, Sheila noticed something odd on the ice-covered lake, so Harry pulled over to the beach, and they got out to investigate. Hovering over the ice was an enormous football-shaped object that rocked back and forth. It was steel gray, with beams of light coming from both ends. The object was slowly descending as it swung one end toward the shore, but as it moved the Bakers heard no sound emanating from it. The couple ran back to their car and drove home, but as they entered their house, which was located close to the lake, they could still see the object hovering over the lake. They called the police and were later referred to the Coast Guard. As they waited for a response from the Coast Guard, five or six

bright yellow triangular objects emerged from the center of the large ship and began to swarm around it. They all then stopped in unison and pointed toward the mother ship. They then all turned and flew in a zigzag pattern, first to the north and then east and finally they turned inland and sped west.

The Coast Guard soon arrived to investigate—towing a Boston whaler, seaman James Power—and Petty Officer John Knaub drove with the Bakers to the beach, where the large craft and some of the smaller triangular objects could still be seen. As they approached, they could hear the ice rumbling and roaring, and the Coast Guard servicemen could see the ice shift dramatically as the object came close to it. The Coast Guard crew were giving a live report to their base from their radio, and the Bakers heard them saying, "Be advised the object appears to be landing on the lake…There are other objects moving around it. Be advised these smaller objects are going at high rates of speed. There are no engine noises and they are very, very low." One of the small triangles then swiftly buzzed the Coast Guard vehicle and then shot back to the mother ship with all the other triangles as the larger object landed on the ice. The mother ship then flashed a series of lights, and the triangles once again reemerged and hovered over it as the lights changed colors. The noise from the ice suddenly went silent, and the mother ship and the triangles then disappeared. Within moments, another similar large object was seen five hundred yards away, moving west across the ice about fifty feet above the ground. It then glided out of sight.

Many times, UFOs are seen entering into the water or exiting and flying into space by witnesses. A search in the MUFON (Mutual UFO Network) database reveals a stunning number of UFOs seen in or hovering over Lake Erie on both the American and Canadian borders. On August 16, 2006, two American couples were boating and anchored on the Canadian side of the lake when one of them saw a giant light emerge from the lake and hover in the sky. She alerted the others to the light, and it shot out of sight into space. One of the witnesses described it as a multicolored diamond-shaped object. One of the witnesses was very moved by the incident, which produced in him insomnia and nervous tension issues, as well as problems with his equilibrium. This object is also similar to the YouTube objects filmed in Cleveland in recent years and was also seen by an amateur astronomer in Erie on March 13,

2010. This witness was stargazing at his home near Chestnut Hill by West Grandview Boulevard when he noticed a multicolored object over the lake. The object was observed for more than ten minutes and was stationary in the sky in its relationship to the stars and planets. Another Erie resident has had ten experiences with the same type of object over the lake, the last sighting being on May 4, 2010.

A different type of object was seen entering the water on February 26, 2006, on the north shore of Lake Erie. At 3:00 a.m., the witness noticed lights in the sky above the lake that plunged into the water. The lights were visibly moving in the water and coming close to the shore. A beam of light was then emitted, and it scanned the hills on the shoreline as if looking for something. The search beam was then extinguished, and the light moved out into the lake and grew faint as it dove deeper in the water. A similar object was seen by a fisherman on Lake Erie on June 14, 2009. As the man was fishing, he noticed a jet with a long contrail on the horizon, and just below it a very bright light seemed to be following it. At first the man thought that it was a reflection from the plane until the light stopped for about ten seconds and moved off at a different angle. The object then flew slowly to the west before once again changing course and quickly flying out of sight to the north.

Two such objects were seen by another amateur Erie astronomer on September 13, 2009, as well. The man and his wife often observed the International Space Station as it crossed the Erie skies, and on this night he noticed two star-like objects descend at incredible speed. The object drew close and leveled off at about two hundred feet and flew over some neighboring pine trees. One of the more well-known UFOs over the Erie area in recent times described another object similar to these. In the morning of November 8, 2010, there was a flurry of reports of a UFO sighted flying over I-90 and heading out toward the lake. There were possibly seven or more of these objects sighted over the city of Erie, in Fairview and on the lake at this time. Many of these sightings were phoned into radio station Star 104 that morning. One local witness described his encounter: "I was looking South from my car, driving on I-90. I saw what appeared to be a large star. I thought it was unusual since the sun was up. It was very large and very bright. Then it moved to the side and then it quickly disappeared. Approximately 2 miles down the road I saw it again."

Is Lake Erie host to a hidden UFO base? UFO researchers have claimed that such cites exist off Gulf Breeze, Florida, Cuba and California, among other locations. Due to the YouTube sensation of the Cleveland UFOs, many also see Lake Erie as a possible site for a hidden base as well. Theories abound as to the purpose and origin of these alleged bases. Some claim that there is a vast underground network of alien bases around the world, some underwater and some in deep caverns connected by thousands of tunnels. Other ufologists hint at an elder race of beings that long ago took to living under the earth to escape global catastrophes that happened either thousands or millions of years ago. This "Chariots of the Gods" theory that has gained popularity in recent years holds that this elder race has been observing and teaching mankind since ancient times and is responsible for the Sumerian legends of the Anunnakki, a reptilian race that taught the ancient Sumerians language and civilization. Still others believe that these underwater bases are survivors of ancient Atlantis and have incredibly advanced technology. Some suggest time travelers or multidimensional adventurers. Of course, many think that they might be just natural phenomena. These UFOs could be some unknown force that mirrors intelligence as the energetic object is thrown about across the sky. Or perhaps it is all a government secret. Conspiracy theories abound concerning black ops funds that are silently shifted into front projects, which in turn go to clandestine military projects. Could Lake Erie house a secret underwater military base that tests new aerial/aquatic technology? The theories to explain the sightings over our lake are legion.

Whatever they are, some odd things were happening on the waters of Lake Erie before the popular notions of aliens, ancient or otherwise, arose. What are they? Perhaps we will never know. Maybe one day we will, but will we be comfortable with the answer?

Strange Creatures

BEWARE THE PHANTOM PANTHERS

Lake Erie is named after the Erie Indians. Ironically, the Eries (often mistakenly referred to as "Eriez" because of a French cartographer's mistake in naming the lake "Lac des Eries" with the "s" accidentally inverted) were never actually known by that name. They were known

by many other names, such as the Eirgas, Eriehronons, Riguehronon Awenrehronons, Rhilerrhonons or Carantouans. "Erie" is a shortened version of Seneca name for the clan, Eriehronon (or Erielhonan). Some have also mistakenly called them the Kahkwas, but this clan was a neutral nation who inhabited the northern side of the lake, though they were strong allies with the Eries and were often lumped together as one nation by enemy tribes. The Eries were a clan or kindred tribe of the Iroquois; each clan had their own tribal name usually signified by an animal, plant or object. Each tribe had an emblem that was a figure of the clan name, be it the clan of the wolf, the clan of the tomahawk or the clan of the corn. This figure was often tattooed on a clansman's body or painted over the entrance to the lodge. The clan figure of the Eries was that of the cat.

The Iroquois Confederacy knew the land of their kindred Eries as the territory of the cats. This was also the name by which the Eries were known by the early French explorers. The Iroquois names Erielhonan, Awenrehronon and Rhilerrhonon literally mean "long tail," referring to the panther in the form of a cougar or mountain lion. In the late nineteenth century, a writer claimed that the cats referred to by the Iroquois and French were not felines such as cougars or panthers but rather raccoons— which were abundant on the lake shore compared to the rarely seen panthers. However, the writer was using his nineteenth-century world to deduce facts about a northwestern Pennsylvania region that preceded the European settlements and pre-Columbian Native American history.

A French memoir written in 1718 relates that just one island on the lake was overrun with wild cats to such an extent that a great number of them had been killed by local Indians over a period of time. If one looks into historical records, it can be noted that panthers were known to many colonists during the early settlement of Pennsylvania, even in the more populated eastern part of the state. Colonist Gabriel Thomas in his 1698 account of the wildlife of eastern Pennsylvania names panthers as being prolific in the area. In fact, Pennsylvania wildlife historian and folklorist Henry W. Shoemaker claimed in his 1917 book *The Pennsylvania Lion or Panther* that "[l]ions in British East Africa were never more prevalent than was the panther in Pennsylvania a century or more ago."

The Senecas believe that the panther is a very spiritual creature. According to ancient Seneca tradition, the spirits of tyrants and

unfaithful queens pass into panthers upon their deaths. This belief may have a bearing on the fate of the Eries, for the tribe was wiped out by the Iroquois in 1653 primarily because their manner of living was considered an abomination to the tenets of Indian life and ethics of the confederacy of the Six Nations.

The Eries were governed by a female tribal leader called Yagowania in the clan dialect and known as Gegosasa by the Senecas. Yagowania was regarded as "the mother of the nations" whose office was that of "keeper of the symbolic house of peace" because she was the official arbitrator between the Hurons and the Iroquois Confederacy, as well as the individuals of those tribes who had a dispute. The chief warrior of the Erie clan was Ragnotha, whose principal residence was in Tushuway, which is now Buffalo, New York. In the midst of wars surrounding them, the Eries maintained neutrality until 1634, when two Seneca warriors came to Yagowania and were well received at her lodge. They were about to smoke a pipe for peace when an envoy from the Massassaugues, a Western Lake tribe, arrived at the lodge and demanded vengeance upon the Senecas for the death of their chief's son by that clan. Yagowania meted out her judgment and deemed that the quest for vengeance was just. The Seneca warriors escaped and notified their tribe of the betrayal of the Erie queen, and the violation of the sacred neutrality of the Eries was spread to all the tribes. Yagowania sent messengers to Ragnotha to ask for assistance. As the Erie warriors traveled down a well-known trail to rally for war, they were ambushed by Senecas, and six hundred of Yagowania's warriors lay dead in the aftermath. Afterward, the Senecas demanded that the Eries repent their decision, but Yagowania refused.

After years of war between the tribes, the Eries finally agreed to make a peace treaty with the Senecas. To ratify the peace between the two tribes, Yagowania sent an envoy of thirty of her tribal leaders to the Seneca capital. While there, a Seneca warrior was killed in a quarrel by an Erie, and in retribution all thirty of the envoys were slaughtered in a violent assault. Thus war once again broke out not only between the Eries and the Senecas, but with the entire Iroquois nation joining against the Eries as well. At one point, a group of Eries captured a famous Onondaga chief and were about to burn him alive when the chief convinced them to choose a path of reconciliation. By Indian tradition, he could take the place of one of the murdered envoys and thus bring peace to the tribes.

It was agreed that his fate would be in the hands of a sister of one of the murdered leaders; she could either receive him with a fraternal embrace or burn him alive in retaliation. However, the sister was away at the time, and there was no doubt with the Eries that she would choose the peaceful alternative upon her return.

The Onondaga chief was thus dressed in festive ceremonial robes, and the whole town celebrated with a feast to honor his newfound adoption into the tribe. To the amazement of the Eries' remaining leaders, when the sister returned she declared that she would be avenged for her loss and insisted that the Onondaga chief be burned alive. The prisoner was stripped of his ceremonial robes and bound to a stake in the middle of the town. He warned his captors with his last breath that they were burning not only him but the whole Erie nation as well, for his tribe would also seek fiery vengeance at his death. His curse upon the Eries came true, for as soon as the word of his death spread, it was then decided by the Iroquois Confederacy that the Eries and the Iroquois could not abide as one nation and that the Eries would not be permitted to exist as a separate one. Their tribal fire was put out, and their name and lineage as a tribe was erased.

In May 1654, an Onondaga orator on a peace visit to the French in Montreal said to the governor, "Our young men will no more fight the French; but…this summer they shall invade the country of the Eries. The earth trembles and quakes in that quarter; but here all remains calm." About 1,800 men were sent against the Eries by canoe, and as they landed the Eries retreated west and fortified their position with a makeshift fort of fallen timber. The Iroquois approached the fort, and two of their chiefs, dressed as Frenchmen, stepped forward and called on them to surrender—one of them implored that if they did not surrender, they were all dead men, for the master of life was on the side of the Iroquois. While the attackers numbered 1,800, the Eries warriors numbered over 3,000, and queen Yagowania herself reportedly replied, "Who is the master of your lives? Our hatchets and our right arms are the master of ours!"

The Iroquois attacked and were met with a heavy volley of poisoned arrows, killing many and forcing the survivors to fall back. After a while, they returned with their canoes over their heads for protection from the arrows. They then threw up the canoes against the fort and used them as ladders to scale the impromptu fort with such ferocity that the Eries retreated in

panic. The Eries were slaughtered, and those who could ran away into the forest to escape. The loss of life was so massive that the Iroquois were forced to remain for two months in the area to bury the dead and care for the wounded. The Eries as a tribal clan were gone forever. Some survivors were adopted into the Seneca tribe, but during the 1720s many left and settled in Ohio, becoming known as the Mingos or Ohio Senecas. In the 1840s, they were forced to relocate into the Oklahoma Indian territories by the United States government. The clan of the cat was gone from the shores of Lake Erie, and the panther was known by the Seneca conquerors as the reincarnate spirit of the unfaithful.

After the tribe vanished from the county, panthers both physical and phantom continued to be seen and haunt the European settlers, who built their dwellings on the ashes of the Erielhonan. Early Pennsylvania settlers had strong superstitions concerning the "painter," as some of the European pioneers used to call the local panther. To them the slaughtered panther became a supernatural spirit that would haunt the area where it met an unnatural death.

Legend has it that in 1864 a Pennsylvania hunter killed a large male panther, stuffed it and mounted it on the ridgepole of his wood house. One night, the dead panther's mate came to the farmer's property, jumped onto the wood house and pulled down the carcass of its dead partner. It carried it off into the hillside, where witnesses claim to have seen it once again alive and running free with its companion. Another legend tells of a panther killed, whereupon the hide was put into an attic to cure. One night, the hunter heard some strange an unnatural noises in the attic; in the morning, he climbed into the attic to find that the hide and the carpenter's trestle on which it was mounted had vanished. Word spread that the unholy manikin was seen by a few travelers roaming the woods at night, as it did when it was alive. It was encountered by a Native American shaman in the forest on a following evening, and the medicine man stopped its preternatural wandering with a single silver bullet. Early German pioneers said that the panther's hide glowed like fox fire at night and green lights burned from the eyes. Some of the first Irish frontiersmen regarded the panther's wailing as that of the banshee, whose mournful wail would foretell the death of a family member.

Sadly, the Pennsylvania panther is all but legend in our modern era. It has been hunted out of existence by pioneers who lusted after its

multicolored pelt and often made a hefty profit from the hides shipped home to western Europe, where they were highly prized commodities. If you ask the Pennsylvania Game Commission, the last Pennsylvania panther was killed in Berks County in 1874. Ask the commission about possible panthers in northwestern Pennsylvania, and staff members will say that that there is no real evidence that panthers ever made the upper northwest portion of Pennsylvania their home. But if you look into the archives of the commission's own magazine *Pennsylvania Game News*, you get a different story. In the January 1968 edition, there is a short report on page forty. Part of the text reports that:

> *a cougar was recently killed in Pennsylvania. On October 28, 1967, while squirrel hunting in Venango Township, Crawford County, John D. Gallant of R.D.3, Edinboro, shot a mountain lion. The animal was five feet three inches long from nose to tip of tail and weighed 48 pounds. The cougar was later examined by Dr. Kenneth Doutt, Curator of Mammals, Carnegie Museum, who said it was six to eight months old.*

While their magazine clearly notes the cougar's killing, the Pennsylvania Game Commission now claims that it was a tame pet that must have been set loose by an unknown private individual. Additionally, the article does omit other details. According to family members at the time, the young cougar was one of two sighted at the time of the shooting. The second cub was also targeted, but the shot missed. Be that as it may, the record does stand that, according to the initial report, the last panther was shot in Pennsylvania in 1967 by an Erie County resident. There are also reports within Erie County of animal maulings occurring within the same time period. Greg Ropp, president of the Erie County Horror Film Festival, remembers a horse being mauled on his parents' property within months of the cougar cub's shooting. Evidence suggested a big cat attack.

There have been panther sightings in Erie County as well, many going far back into the county's history. John G. Carney wrote in his 1958 book *Tales of Old Erie* of many encounters with big cats in the region. In one of these, he recounts the story of a large panther being sighted near the town of Albion. It was seen in the valley north of the town, and sightings continued for quite a long time. At about the same time, reported sightings were coming in from other parts of the county.

Along with physical big cats being sighted in the county, there have been many sightings of phantom panthers. Also known as "alien big cats," this is a worldwide phenomenon that frequently occurs in Hawaii, Denmark, Finland, Australia, New Zealand, Ireland and Great Britain. In the United States, the sightings seem to be centered in central and southern Illinois. During the 1950s and 1960s, reports of panthers in Illinois turned up almost monthly. Here in Erie County, Pennsylvania, the sightings have been rumored for centuries, but only recently have actual witnesses come forward.

In 2000, an anonymous witness was driving his car on a country road in southern Summit Township during a warm summer evening. There was a rush of movement in front of his car, and he saw a huge, dark cat in his headlights. The cat took up the entire road from head to tail. It stared straight at him and hissed, its green eyes glowing ominously. The animal

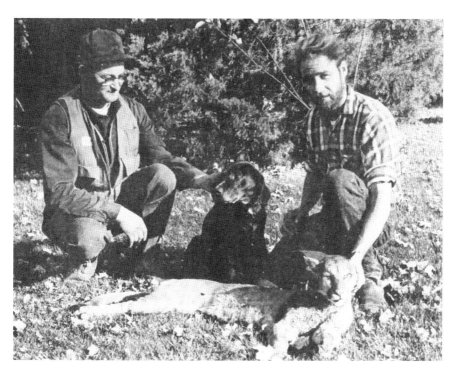

John Gallant (left) and the cougar cub shot in 1967. *Courtesy of the* Pennsylvania Game News.

did not move, and he quickly swerved to avoid a collision when the animal simply disappeared into thin air.

Another incident took place in 2002. The details were very brief, simply reporting that a group of teenagers encountered a large cat circling their campfire near Edinboro. It was estimated it was over six feet long and "melted" into the darkness. Recently, there was a sighting in urban Erie itself. On February 7, 2010, a part-time pharmacy delivery driver was driving on Melrose Avenue between Thirty-ninth and Fortieth Streets going south at about 2:30 p.m. The driver noticed a strange shape in front of his vehicle passing east to west on Forty-second Street. At first, the witness thought that it might be floating garbage bags going across the street, but he then noticed a rhythmic movement to the motion. He also noticed a head, front and rear haunches and a long tail as the black shape moved across the street in front of him. It had recently snowed the day before, and the creature disappeared behind a large pile of snow on the west side of the road. When the witness pulled up to the area, there was nothing to be seen—no footprints of any animal and no dark debris that might have been mistaken for a catlike creature crossing the road. The whole encounter lasted just a few seconds, and the witness was himself very skeptical at what he was seeing at the time. However, he could not deny what he had encountered and even repeatedly traveled the same route to make sure that it was not a mirage or illusion. But the witness was sure that he had seen a large phantom black panther walking the snow-covered Melrose Avenue that February afternoon.

The cursed Erie Indians were the cat people. During their time in the county, there is evidence that panthers roamed the county freely. Are the phantom panthers that have been sighted some kind of spiritual residue of the cursed tribe? Or is it some kind of natural phenomenon that records history and then plays it back? (Many paranormal investigators would call this a residual haunting.) Whatever it may be, beware the phantom panthers; they still roam Erie County.

BIGFOOT LURKS IN ERIE COUNTY

Although there have been legends of wild men or hairy giants in Native American lore and early settler history in the early United States, the Sasquatch or Bigfoot has only been popular in the public consciousness for the last fifty to sixty years. In 1958, Bigfoot hit the national news after footprints were found around an isolated worksite in Bluff Creek, California. In 1967, Roger Patterson and Robert Gimlin filmed the now famous Bigfoot film that has become iconic with the legend. After these incidents, the creature was forever imbedded in American lore. At first, most reports of Bigfoot came from the big woods of the Pacific Northwest, but soon sightings of the creature were reported from all over the country. From the skunk ape of the Southeast to the grassman of the Midwest, giant hairy bipedal humanoids have been sighted in all four corners of our country, even here in Erie, Pennsylvania.

Eric Altman, director of the Pennsylvania Bigfoot Society, has noted an increase of Bigfoot sightings in our western part of the state in the last few decades. One theory as to why our area is quickly becoming a

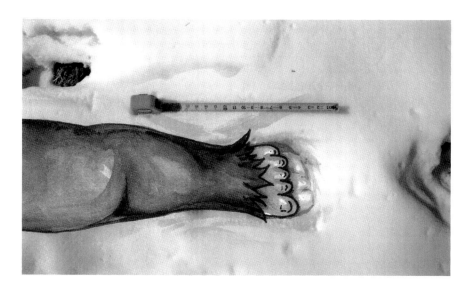

A Bigfoot print (plus Bigfoot himself?) from Western Pennsylvania. *Courtesy of the Pennsylvania Bigfoot Society; additional illustration by Karleigh Hambrick.*

hot spot for Sasquatch sightings is climate change; these creatures tend to thrive in woodlands with a high level of precipitation and an abundance of vegetation and small game on which to feed. Western Pennsylvania has become, over the past few decades, one of these "green areas" that are perfect habitable areas for Bigfoot. Of course, they are perfect for humans, as well, which could lead to many strange encounters. Indeed, Eric Altman reports that of all the sightings that have been brought to the attention of the Pennsylvania Bigfoot Society, the ones from Erie County, are the most bizarre. Here are the details of some of these reports.

December 1988, Penn State–Erie's side of Wintergreen Gorge, near the foot of the "Devil's Backbone": Two young men went hiking in the gorge and camped out in the dead forest across from the cemetery under the ridge called "Devil's Backbone." At about midnight, an eight-foot-tall creature with a conical-shaped head was seen on the ridge silhouetted by the moonlight; it began to make bloodcurdling howls until the boys fired a gun in its direction. For two hours it would repeatedly come back and howl, waving its overly long arms in the air and retreating at the gunfire.

Fall 1989, one mile southeast from Penn State–Erie on Station Road in Harborcreek: A teenager was dropped off by friends at dusk and waited on the front porch for his parents to return to their home, which was situated on fifty-six acres of land. The boy heard crashing in the woods to his left and saw a large figure walking quickly through the woods about fifty to sixty yards away from him. It took huge steps and had long arms swinging at its side. The teen stood up and was going to get a better look when the creature stopped and took a few steps toward him. It was eight to nine feet tall, had almost no neck, was covered with hair like a gorilla and had glowing red eyes. They looked at each other for about thirty seconds, and then the creature quickly ran back into the woods and disappeared. After investigating the area later, the teen found footprints and noticed that the beast had been walking along a deer trail when he first witnessed it.

March 2001, Edinboro: As two boys were riding dirt bikes in the woods, one of the bikes stalled. As they tried to get it started, they noticed that the woods had fallen eerily silent, and they felt like they were being watched. Within moments, they began to hear branches breaking, leaves rustling, heavy

breathing and grunting coming from somewhere in the nearby area. They hastily got the bike running, and as they left the area, one of them looked back to see a gigantic hairy biped standing twenty to thirty feet behind them in the woods.

August 2004, Footmill Road in Summit Township: A man and his son were traveling north on Footmill Road when they noticed a large figure standing on the west side of the road. It was an eight-foot-tall creature covered in brown hair, with overly long arms. It seemed to be reaching into a tree for something, and as the driver slowed the car down for a better look, the creature quickly turned and ran away into the woods. The man had experiences with bears and was sure that this was something completely different. It had manlike arms, with fully developed biceps and forearms, and had a flat, humanlike face. At a later time during the evening as they traveled down the same road, something hit the back of their car, leaving a huge dent.

January 22, 2006, East Springfield, near Route 5: As a young couple were going on an evening walk at about 7:20 p.m., the woman noticed a seven- to eight-foot-tall, heavily built creature with dark-brown hair cross the road twenty to thirty yards ahead of her and walk into the woods. It smelled like garbage and made a high-pitched yelping sound. The witness said that she had heard that some of her ancestors had also seen a similar creature in the area long ago.

February 18, 2006, Cranesville, Platz Road, near Route 18: A husband and wife were building a tree stand at 7:30 a.m. when the wife noticed a seven-foot-tall creature with dark, dirty-brown hair as it came out of the tree line near them. It noticed them, made a large howl and then quickly ran away. It had very dark eyes and large feet and smelled like fish; as it ran away, its hands were dangling below its knees.

November 1, 2006, West County, near Sterrettania Road: A young boy was watching deer in a field near his home when he noticed that the deer suddenly ran away as if startled by something. He looked around and saw a seven-foot-tall hair-covered humanlike being walk up a hill. Its hair was dark black, and it made a whooping sound as it crossed over the hill.

September 25, 2008, Arbuckle Road, between Lake Pleasant Road and Footmill Road: A young boy was hunting small game with a pellet gun when he heard something coming through the brush behind him. He called out and heard no reply; then, as he heard the footsteps behind him again, he quickly turned around and saw an apelike face staring at him over the brush. The creature was between seven and eight feet tall and covered in black hair, with black skin; it quickly ducked and the boy ran home.

November 19, 2008, Station Road, east of Penn State–Erie: A man walking on his stepfather's property early in the morning saw a dark-brown shape moving in the trees and heard a deer yelp and stop as if it was quickly killed across a ravine. Then there was a screeching from both sides of the ravine that sounded like a "monkey house," he walked up the trail and saw a large tree being shaken violently back and forth. The same person has had sightings previously and found gigantic footprints on the property.

It is interesting to note in these reports that there is a pattern to the appearances. The creature seems to stay on one side of the county for a period of time. Is it moving from feeding ground to feeding ground? The one witness who had experiences on Station Road in 1989 and in 2008 claims that the creature is often sighted in the area. It is noted that there is a very active deer trail on the property as well. Is this old farmland in Harbor Creek a Sasquatch feeding ground? It is also interesting that the creature is often seen by unsuspecting hunters. Is it because the hunters are venturing into the wild areas of the county or that the hunters are *also* traversing the populated deer trails in search of the same game?

Some claim that the giant skeletons found in old Indian burial mounds in the nineteenth century were actually Bigfoot remains. Many Bigfoot sites also relate the Seneca tale of the Stone Giants as well. However, the settlers who found the giant bones described them as large human bones, without any variance in the skull that one would think would be evident with firsthand descriptions of Sasquatch. Seneca legends of the Stone People also describe giant humans, not hair-covered wild creatures. It would therefore seem logical that these historical anecdotes describe something other than Bigfoot or related kin.

If you venture forth in Erie County's many forested areas, keep an eye out for a large brown or black creature. It may have an eye out for you. If by chance you do see a Bigfoot in your woodland journeys, do not forget to tell Eric Altman at

the Pennsylvania Bigfoot Society. Perhaps then, one day, with a lot of research and fieldwork, the mystery of Erie County's Bigfoot will be solved.

Strange Birds Wing Across the County

The Thunderbird is one of the more familiar Native American legends. While primarily common to the tribes of the Pacific Northwest and Southern Plains, the legend of the Thunderbird was known almost universally among the native tribes of North America. Along the Great Lakes, the legend of the Thunderbird was especially prevalent.

The Thunderbird of lore is a giant supernatural bird that gets its name because it was so massive that the flapping of its wings created thunderstorms and strong winds. Like an odd mix of the Norse god Thor and the Japanese movie monster Rodan, this giant bird's wings moved clouds as it flapped, and lightning bolts would flash from its glowing eyes as it blinked. It is also a very wrathful spirit. To stir the great bird's anger was certain doom. It would mete out judgment for other spirits, bringing lightning down upon the household of the offender or carrying off their children in bloody retribution. It was a messenger of the Great Spirit that could travel the skies in the blink of an eye to relay messages from one earthbound spirit to another. Lakota tradition holds that in ancient times the Thunderbird destroyed a race of evil reptilian creatures called the Unhcegila that lived in secret places in the bowels of the earth and were responsible for mysterious disappearances and unexplainable deaths.

The Thunderbird is not just limited to legends in a supernatural vein in Native American lore. There are many stories of these giant birds harassing communities and carrying off small children and animals to a certain death. The Illini tribe of southern Illinois tells of the Piasa, a gigantic bird that lived in a rock cave lodged in the cliff side of the Mississippi river near present-day Alton, Illinois. Piasa is supposedly translated as "bird that eats man," and the local legend states that in pre-Columbian times the Piasa was the scourge of the native population, taking many to their death in the high cliff-side cave. Hundreds of

warriors attempted to slay the foul bird, but all failed. Soon entire villages were decimated by the terror from the skies.

At this time, famed Illini chief Ouatoga wandered into the wilderness alone to fast and pray to the Great Spirit that he would rescue his remaining people from the horror of the Piasa. On the last night of his fast, the Great Spirit appeared to Ouatoga in a dream and advised him to gather twenty of

Dakota tribal representation of a Thunderbird, shooting lightning as it flies. *Courtesy of the Library of Congress.*

his bravest warriors and arm them each with a bow and poisoned arrows. Ouatoga was told to conceal them in the edge of a great forest, and one lone warrior was to stand in open view by the forest edge as a victim for the Piasa. The warriors were assembled, and Ouatoga offered himself as the victim. Standing alone in the open with his noble warriors waiting to strike in the woods behind him, the chief saw the great bird perched on the cliff eyeing its prey. With a mighty leap, the Piasa took to the air, circling above the plain. Ouatoga began to chant the warrior death song, and the bird quickly descended in a quick dive. Just before its deadly talons were about to grab the chief, all of the warriors let loose their bows, and a hail of poisoned arrows pierced the giant bird. The Piasa let out a monstrous scream and died. In 1673, Father Jacques Marquette, in recording his famous journey down the Mississippi River with Louis Joliet, described a birdlike monster painted high on the bluffs along the Mississippi River:

> *While skirting some rocks which by their height and length inspired awe, we saw upon one of them two painted monsters which at first made us afraid, and upon which the boldest savages dare not long rest their eyes. They are as large as a calf, have horns on their heads like those of a deer, a horrible look, red eyes, a beard like a tiger's, a face somewhat like a man's, a body covered with scales, and a tail so long that it winds all around the body, passing above the head and going back between the legs, ending in a fish's tail. Green, red and black are the three colors composing the picture.*

Father Marquette was describing the painting of the Piasa that now stands restored on the Mississippi cliff. Modern explorers have found a nearby cave, the floor covered in human bones. The remains have since been carried away, but Professor John Russell of Bluffdale, Illinois, wrote of his excavation in 1836, stating that there were remains of thousands of humans scattered about on the cave floor. No indication was made by Professor Russell about marks on the remains that would show evidence of a giant bird feasting on the bodies.

Modern stories of Thunderbird sightings come from across the United States. The sightings seem to emanate from the same areas where Native American legends were plentiful.

THE PACIFIC NORTHWEST: There have been numerous reports of giant birds sighted in Alaska. The *Anchorage Daily News* reported in 2002 of sightings three hundred miles to the west of Anchorage in the villages of Manokotak and Togiak. One incident was reported by a pilot flying a Cessna 207 who reported seeing a bird flying that was about the same size of his airplane, which would make the bird have a fourteen-foot wingspan. Another pilot and his passengers saw a bird of a similar size from a one-thousand-foot distance; they claimed that it was three times the size of a bald eagle.

THE SOUTHWEST: In the mid-1980s, a young boy in San Benito, Texas, witnessed colossal birds flying in and out of the clouds over his home. He remembers screaming to his cousins, "Look! Pterodactyls!" because that was the only creature to which he could compare them.

The July 28, 2007 edition of the *San Antonio Journal* contained a report titled, "Sightings of Mysterious Giant Bird Continue in San Antonio" that detailed sightings in the area from 1976 until the beginning of 2007.

THE MIDWEST: One of the most famous Thunderbird sightings happened on July 25, 1977, at Lawndale, Illinois. Three boys were at play in a suburban backyard, and at about 9:00 p.m., two large birds swooped down and chased the boys. Two of the children escaped unharmed, but ten-year-old Marlon Lowe was almost taken away by one of the colossal birds. The bird clamped his shoulder with its claws and then lifted the boy two feet off the ground, carrying him across the yard. Lowe hit the bird repeatedly, and it released him and flew over the horizon.

On the first week of September 2009, an air force officer stationed in Minot, North Dakota, was taking a break near the fence line of the base when he saw a silhouette in the moonlight. He thought that it was a glider, so he pulled out his night-vision equipment from his Humvee and was startled

to see a gigantic bird with a twenty-foot wingspan slowly glide across the sky. He observed it for several minutes as it slowly flapped its wings and gently flew toward Canada.

On May 3, 2010, a goat farmer in McHenry, Illinois, saw a number of birds circling swiftly in and out of the overhead clouds at about 3:45 p.m. The farmer estimated their size at about half that of a twin-engine aircraft.

PENNSYLVANIA: Our state has a rich history of Thunderbird sightings, most of the sightings coming from areas known as the Black Forest region, which encompasses Clinton, Potter, Lycoming, Tioga, Cameron and McKean Counties. These areas are sparsely populated state forest and game lands. But there have also been other sightings in more populated areas.

In the early 1940s, writer Robert R. Lyman spotted a Thunderbird sitting on a road near Coudersport, Pennsylvania. As it flew off into the sky, he noted that the creature had a twenty-foot wingspan.

In 1945, a young schoolgirl was dropped off by her school bus driver when she saw a huge shadow cross over her path. She looked up to see a huge bird, larger than any eagle or buzzard she had ever seen. It did not flap its wings but rather glided in a circle until it was lost in the trees.

In 1969, the wife of a Clinton County, Pennsylvania sheriff saw an enormous bird flying gently over Little Pine Creek near Pine Creek Gorge. The witness claimed that the bird's wingspan appeared to be as long as the creek was wide, which would be about seventy-five feet.

In 1973, a man was driving his car in a rural area when he noticed what he thought was an airplane flying next to him in a field. The bird was gliding about ten feet off the ground and did not flap its wings, and it tipped and turned toward a farm. The creature was a dark shade of brown, with a huge beak and a wingspan of about twenty feet. It soon disappeared into a wooded area near a barn.

In November 2004, a man was sitting in heavy traffic at a construction zone in a Pittsburgh suburb. He noticed what he believed to be a small aircraft flying overhead, but he was startled to see the figure flap its wings. The bird was incredibly huge, which was described as being longer and wider than a bus, with a wingspan approaching thirty feet. It circled for five to ten minutes and then drifted off to the west.

On May 7, 2010, a night watchman was making his rounds at about 1:00 a.m. at a Pittsburgh facility. The watchman heard a screech and looked up

to see a large bird fly overhead. Using his binoculars, he noticed that it was grayish-brown, with an enormous wingspan.

In the summer of 2001, western Pennsylvania experienced a flurry of Thunderbird sightings. All of them describe a similar creature, and one of the sightings came from Erie County.

On June 13, 2001, a resident of Greenville looked up to see what appeared to be a small plane, but he soon realized that it was actually a very large bird. The witness observed the bird for at least twenty minutes, clearly seeing its gray-and-black feathered body and estimating its wingspan to be about fifteen feet and its body length at about five feet. The next day, the witness's neighbor also saw the giant bird perching on a tree for about fifteen minutes before flying off to the south. The neighbor exclaimed that it was the biggest bird he had ever seen in his life.

On July 6, 2001, a caretaker for a cemetery situated near I-90 in Erie County's Summit Township was mowing an unused twenty-three acres of land in the northern portion of the graveyard near the Chicago to New York high-tension line. About twenty-five yards to his right, he noticed a rustle in the brush just east of the closest high-tension platform. A gigantic bird lifted off from the brush and quickly gained height until it passed just above the uppermost crossbar of the high-tension platform. The witness noticed that the bird's wingspan was very close to the width of that uppermost bar. The bird had a primitive appearance; it was black or dark gray, with a tuff of white under its very thin and pointed beak. It seemed to have no neck at all, and its legs seemed to be tucked close underneath its body. The witness also noticed a long tail that ended in a diamond shape. After the bird soared up over the high-tension platform, it quickly descended to the west into a wooded area that contained the cemetery's dump for excess grave dirt. The caretaker had seen large birds before, since the area has been host to many blue herons, many of which he had encountered at a very close range. But this creature he encountered was of a tremendous size. Later he measured the length of the upper support bar that closely matched the bird's wingspan. The bar was a little over twenty feet long, and the witness estimated that the bird had to have had at least a fifteen- to seventeen-foot wingspan at a minimum.

On September 25, 2001, a nineteen-year-old man also had an encounter near Route 119 in South Greenburgh near Pittsburgh. The witness first heard a loud sound like thunder and looked up to see a huge black and grayish-brown bird about fifty feet overhead. The witness described the

The high-tension wires where the Erie County Thunderbird was sighted. *Photo by Robin S. Swope.*

bird as horrifically flapping its wings very slowly and then gliding above the passing big rig trucks. He estimated the wingspan to be about fifteen with a head that was about three feet long. The bird then flew into a wooded area and landed on a dead tree's branch that immediately broke under its weight. The creature then flew off out of sight.

The next month, in October 2001, a young couple was driving at night through New Wilmington. It was between 2:00 and 3:00 a.m., and there was a full moon. They were on a country road when they heard a giant flapping of wings, and a large bird flew directly over their SUV. Its wingspan was from thirteen to sixteen feet, and it had a grayish color. It had long, dangling feet, which reminded the woman of a man's legs. The bird landed on a barren tree that almost matched it in color, and they lost sight of it in the dark.

It seems as if all four of these sightings describe the same large bird. The color, the wingspan and other details resemble one another strikingly. Perhaps the bird was migrating, or maybe they were all separate birds of an as of yet unknown mystery species. That would seem to be the case, since in the

spring of 2009 the Erie County Cemetery caretaker had another encounter with a large bird at the same place as he had in 2001. He was on a roadway that was situated between the cemetery's mausoleum and the high-tension wires when a large bird of the same color and proportions lifted off. Instead of flying over the wires to

the west, the bird quickly flew up, gaining altitude very quickly. It was being harassed by smaller birds that were diving at it, and it soared to a great height in a very short time. Strangely, the caretaker had a digital camera on his person at the time, for he was there to take pictures of the mausoleum. However, when he attempted to take a photograph of the bird as it lifted off, the batteries in his camera unexplainably died. He insisted that they were new batteries and that he had just installed them in the camera. It was as if something had drained them in an instant. By the time he went to his car and reloaded the camera with fresh batteries, the bird was but a speck in the sky.

Oddly, this was not the only odd bird the caretaker had noticed while attending the cemetery grounds. In about 2005, he was heading toward the cemetery dump with a load of dirt when he noticed an odd little bird walking alongside his truck. It was about the size of a chicken, with oily, gleaming feathers like a pigeon. Those feathers were a dark brown, and its wings were small and tucked to the side, as if it were flightless. The body's shape was very similar to a pigeon's also, but more elongated and with a smaller breast. The legs were dark black, and the beak was small and pointed, with a very vibrant orange color. The strange little bird waddled along with the truck as the caretaker slowed down to observe the odd little fowl. It did not hurry from fear of humans like most birds; instead it only cleared the side of the dirt road when the truck went into the tree line. When the caretaker returned down the dump entrance, the bird was gone, and he has not seen it since. He contacted the Pennsylvania Game Commission to ask what kind of bird this might be since he had never seen its like before. The commission had no idea; it resembled nothing ever reported in Pennsylvania. The caretaker

also posted a digital reconstruction of the bird on the website of famed cryptozoologist Loren Coleman (Cryptomundo.com). No one there was able to come up with a positive identification for the mysterious fowl either.

Curiously, another cemetery custodian, Russell Cornwell, has also had an encounter with an odd bird. While traveling home late one night in the late '90s, Russell was driving on a country road. To his right on the side of the road, his headlights revealed a gigantic owl. In his estimation, the owl was the size of a human being, almost six feet tall. It startled him so much that he almost lost control of his vehicle and drove off the road. Although the bird was not the normal description of a Thunderbird, its size was indeed amazing.

What are the Thunderbirds seen across the United States? Some compare the descriptions of the Thunderbird with the extinct Teratorns. Teratorns were very large birds of prey that lived in North and South America from the Miocene to the Pleistocene era. They are related to the condor but were much larger. Four species of the Teratorns have been discovered, and their wingspans ranged from thirteen to twenty feet. They had a typical condor appearance, with dark gray or black feathers and a tuff of white under its long, featherless head. It seemed to be a perfect match.

However, there is another contender for what the Thunderbird could be. In 1984, while excavating at the Hiscock archaeological site near Byron, New York, in Genesee County, Dick Laub of the Buffalo Museum of Science made an interesting find. He uncovered a bone that he thought belonged to a deer-like animal because of its size. But upon examination, he realized that it was from a large bird, perhaps a vulture. He then sent it to the New York State Museum, which identified it as the humerus of a California condor. Within the next two years, additional remains were found that confirmed the presence of the condor in ice age New York. Could the condor still roam past its traditional range in the western United States? This still does not explain the extreme size of the large birds sighted and categorized as the Thunderbird. The condor's wingspan only slightly exceeds ten feet at the most. The creatures sighted are usually twice that size.

In the summer months in Erie County, if you wander in the woods or less traveled spots, keep an eye on the skies. Perhaps you will see something astonishing. You might see something that should not exist—something that should be extinct. Perhaps you will see a Thunderbird gently gliding by.

Conclusion

E rie County has a rich multicultural history that reaches back in time to eons past, where unknown wanderers made the lakefront their home. Often the legends from the past have no documented record that we can simply access. Many of the early county records were lost in the courthouse fire of 1823. Who knows what valuable treasures of our history were lost to time in that fire? Perhaps there were records that could have validated the findings and possibly the whereabouts of the giant skeletons found in so many mounds around the county. Perhaps there were documents that detailed the burials of the *Niagara* crew in Graveyard Pond. Alas, we shall never know.

Most of the unexplained events documented in this book are very subjective. Stan Gordon, Pittsburgh-area ufologist and Bigfoot investigator, recalled a case in the '70s in which a number of people who were gathered together were witnesses to a UFO. However, not everyone present saw the UFO, only a select portion. Why? Interestingly, many who have an encounter with a UFO or Bigfoot begin to become sensitive to perceiving unexplained phenomena. Some people are born "sensitive," or have spiritual gifts that are described in 1 Corinthians 12 that allow then to sense or "discern" spirits. Most individuals with spiritual gifts experience their influence in their life when they make a deeper spiritual commitment to their life. Some call it an "in filling of the Holy Spirit." Others have had the gifts since a child, and they grow into their abilities. Many will never have a paranormal or supernatural experience in their life.

I have had numerous personal experiences with unexplained phenomena. As a child, I was a huge fan of the television series *In Search Of*, hosted by Leonard Nimoy. Initially attracted to the show because *Star Trek*'s Spock was hosting it, the series introduced me to Bigfoot, UFOs, unexplained phenomena and the like. I never had an experience with the unknown myself until I had a spiritual awakening and went off to a Christian college. There I was introduced to spiritual warfare and had close encounters with malevolent spirit as I studied exorcism in seminary. In fact, I had an encounter with a UFO flying over the Hudson River Valley in the mid-1980s while going to my dorm room after a prayer meeting. It was during the famous Hudson River Flap, and I saw a gigantic triangle slowly cruise over the river and pass overhead to the mountain behind our college. Thousands saw the UFO and reported it to the police. I myself tried to point out the oddity to other passing students; most just nodded and said it was weird but mostly ignored it. Having grown up by the Erie Airport, I knew that it was not a plane. I never believed in ghosts, until 1996, when I had a personal encounter at the now defunct "Med-Stat" ambulance company. I experienced phantom footsteps and a door handle jiggle, with nobody there. It was an perplexing experience; I thought that if I would ever encounter a ghost, I would get the same unsettling feeling when I had encountered malevolent spirits. But I did not.

There are three experiences chronicled in this book for which I was the witness. I had the experience with the phantom panther in the middle of the day in suburban Erie. It was very surreal. I was sure that it was either a group of garbage bags or an incredibly large dog. The incident only took a few seconds, and a few more after that I was at the crossroads, where I saw the figure move. There was absolutely nothing in sight. I searched the area, to no avail. I really had no idea what I had just encountered; I had never seen anything like it before. It looked like a dark shadow of an animal skulking across the road. Later that night, I received a message from author Jason Offutt, author of *Darkness Walks: Shadow People Among Us*, asking for assistance with an encounter with a malevolent entity. When I described what I had just seen, he told me about shadow animal stories he had recently published. Finally it all clicked. I had heard of phantom panthers, but I never really found them interesting. I had always thought that most people were mistaking common house cats for larger felines. But what I saw spanned the road from side to side.

Other incidents that I was witness to were both the Thunderbird and the odd little bird in the cemetery. I always thought it odd that I never had

a spooky experience while working at a graveyard. Instead, the cemetery by the busy highway was almost a nature preserve. We had peacocks and pheasants flying over the fence from I-90, coyotes rolling in the grass just feet from the lawnmowers and groundhogs falling out of trees. It never ceased to amaze me how much wildlife made its way through that cemetery, even though tons of metal were hurling themselves across the pavement just feet away. I had seen blue herons very close up; one used to catch fish in the stream next to one of the roads, and many times they scared the living daylights out of me when I surprised them by passing by. But the giant bird I saw that July day in 2001 and again in the spring of 2009 was three times the size of a heron. It was also a very different type of bird. Was it a vulture or one of its giant ancestors? The sightings were so fleeting in both incidents that I can't say for sure. All I know for sure is that it was strikingly huge. Of the little bird, Cryptomundo called it "Pastor Swope's Bird," and many of the comments suggested that I had actually seen a chicken. However, as someone who was raised on a small farm with chicken coops filled with hens and a rooster or two, that was no chicken. It was as if a finch had mated with a pigeon and had an abominable offspring. It was cute and friendly but definitely eerie as well.

I hope you enjoyed the book. Remember to be aware of your surroundings. You are surrounded by the mysterious and the unexplained. As Jesus said, "He who has eyes to see, let him see."

Bibliography

BOOKS

Bruchac, James, Joseph Bruchac and William Sauts. *When the Chenoo Howls: Native American Tales of Terror*. London: Bloomsbury Publishing, 1999.

Carney, John G. *Tales of Old Erie*. Erie, PA: Advance Printing and Litho Company, 1958.

Curtin, Jeremiah. *Seneca Fiction, Legends, and Myths*. Washington, D.C.: Government Printing Office, 1918.

Frew, David R. *Long Gone: The Mystery of the Marquette & Bessemer No. 2*. Erie, PA: Erie County Historical Society, 2002.

Gourley, Jay. *The Great Lakes Triangle*. New York: Fawcett Books, 1977.

Grumley, Michael. *There Are Giants in the Earth*. Garden City, NJ: Doubleday, 1974.

History of Erie County. Chicago, IL: Warner and Beers Company, 1884.

Miller, John. *A Twentieth Century History of Erie County, Pennsylvania.* Chicago, IL: Lewis Publishing Company, 1909.

Miller, Randall M., and William Pencak. *Pennsylvania: A History of the Commonwealth.* University Park: Pennsylvania State University Press, 2002.

Parker, Arthur Caswell. *The Code of Handsome Lake, the Seneca Prophet.* Charleston, SC: Forgotten Books, 1913, reprint 2008.

———. *Seneca Myths and Folk Tales.* Buffalo, NY: Buffalo Historical Society, 1923.

Quayle, Stephen. *Genesis 6 Giants: Master Builders of Prehistoric and Ancient Civilizations.* N.p.: End Times Thunder Publishing, 2002.

Reed, John Elmer. *History of Erie County, Pennsylvania.* Topeka, KS: Historical Publishing Company, 1925.

Shoemaker, Henry W. *The Panther and the Wolf.* Altoona, PA: Altoona Tribune Publishing Company, 1917.

———. *Pennsylvania Wild Cats.* Altoona: Altoona Tribune Publishing Company, 1916.

Wincik, Stephanie. *Ghosts of Erie County.* Girard, PA: One Horse Press, 2002.

INTERVIEWS

Duda, Steve. Interview with author, April 2011.

Gordon, Stan. Interview with author, March 2011.

LaBelle, Gerald. Interview with author, June 2008.

Lane, Fred. Interview with author, July 2010.

NEWSPAPERS

Erie Times News. "8 Others See UFO." August 1, 1966.

Frabrizio, Victoria. "Axe Murder Hollow: The Legend, the Reality." *Erie Times News*, October 31, 1988.

Hahn, Tim. "Cold Case: Ship Lost on Lake Erie." *Erie Times News*, December 9, 2009.

Page, Margie Trax. "Massive Search Finds No Sign of Plane Crash." *Star Beacon*, November 13, 2008.

Terry, Shelly. "More Sightings Surface." *Star Beacon*, November 20, 2008.

———. "UFO Group to Discuss Madison Mystery." *Star Beacon*, November 16, 2008.

ONLINE SOURCES

About.com. "The Giant Thunderbird Returns." http://paranormal.about.com/library/weekly/aa100801a.htm.

Godlike Productions. "Lake Erie Lights, 1867 Newspaper Article." http://www.godlikeproductions.com/forum1/message1283095/pg1.

Michigan Chronoscope—Stories on the Fringe of History. "Great Lakes Thunderbird." http://bigprairieprepress.com/publishing/epress/chrono2/page4.html.

MUFON. "Mufon Case Management System." http://mufoncms.com.
Native Dreams and Visions. "Legend of the Great Bird." http://hub.webring.org/hub/nadreams.

Ohio History Central. "1882 Lake Erie Mystery Wave." http://www.ohiohistorycentral.org/entry.php?rec=3401.

Paranormal Suite 100. "Lake Erie Lights." http://www.suite101.com/content/lake-erie-lights-eerie-a113487.

Pennsylvania Department of Conservation and Natural Resources. "Presque Isle State Park History." http://www.dcnr.state.pa.us/stateparks/parks/presqueisle/presqueisle_history.aspx.

Pennsylvania Find a Case. "COMMONWEALTH v. BIEBIGHAUSER (01/19/73)" http://pa.findacase.com/research/wfrmDocViewer.aspx/xq/fac.19730119_0040087.PA.htm/qx.

Steve Quayle website. "Skull of Giant Man Found in 1940." http://www.stevequayle.com/Giants/N.Am/Victoria.Cty.TX.giant.html.

UFOs Northwest. "Sightings Reports 2006." http://www.ufosnw.com/sighting_reports/2006/wheatleyontca02252006/wheatleyont0224252006.htm.

UFOs Northwest. "Sightings Reports 2010." http://www.ufosnw.com/sighting_reports/2010/eriepa11082010/eriepa11082010.htm.

Unexplained Mysteries Forum. "Coast Guards Witness UFO over Lake Erie." http://www.unexplained-mysteries.com/forum/index.php?showtopic=172758.

Wednat Confederacy. "Oral History." http://ishgooda.org/huron/news86c.htm.

About the Author

Robin S. Swope is a writer and has been a Christian minister for more than nineteen years in mainline, evangelical and independent denominations. He holds a BA in biblical literature and a master of divinity degree in pastoral ministry and counseling. He has served as a missionary to Burkina Faso and has ministered to the homeless in New York City's Hell's Kitchen. He is the founder and chief officiate of Open Gate Ministerial Services and a Church Council member and pulpit minister of St. Paul's United Church of Christ in Erie, Pennsylvania. He is also a freelance journalist for Examiner.com, has a column in the *Tri-State Senior News* and has also written for *Fate* magazine. His published books include *A Walk with an Angel*, *An Exorcist's Field Guide* and *True Tales of the Unexplained*. He has also contributed to Brad Steiger's "Real" paranormal book series, including the bestseller *Real Vampires*.

Visit us at
www.historypress.net
..
This title is also available as an e-book